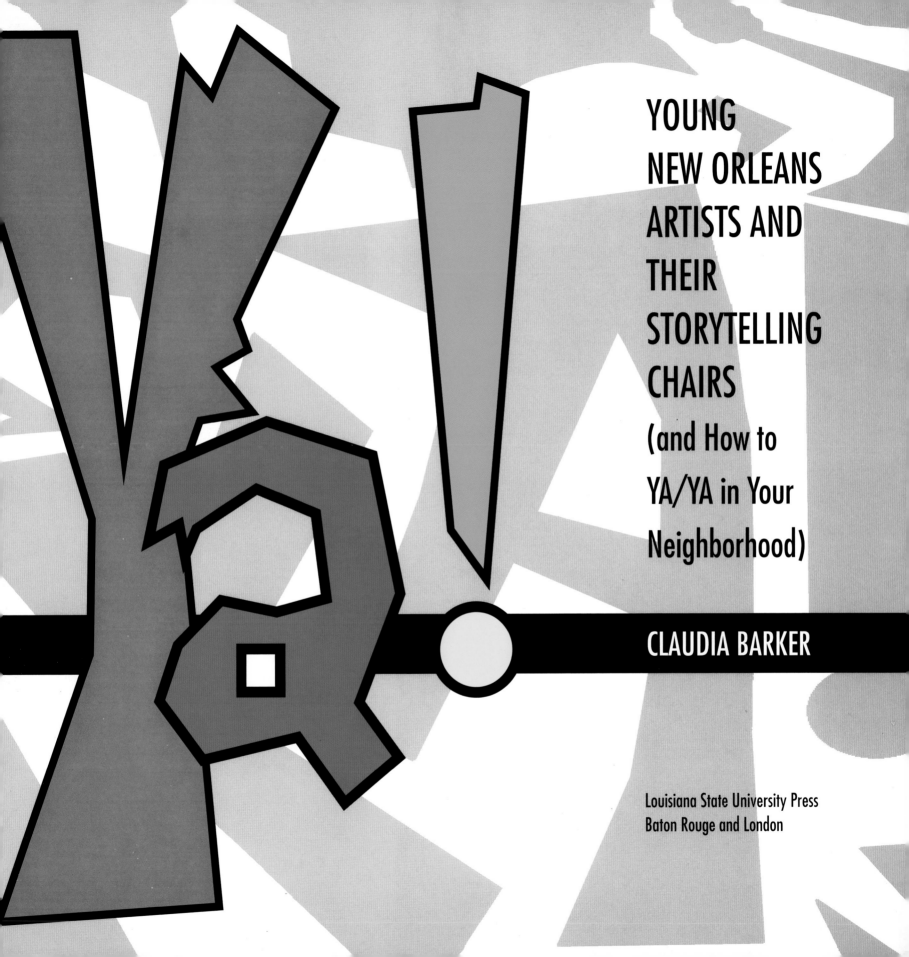

YA!

YOUNG
NEW ORLEANS
ARTISTS AND
THEIR
STORYTELLING
CHAIRS
(and How to
YA/YA in Your
Neighborhood)

CLAUDIA BARKER

Louisiana State University Press
Baton Rouge and London

Copyright © 1996 by Louisiana State University Press
Manufactured in Hong Kong
First printing
05 04 03 02 01 00 99 98 97 96 5 4 3 2 1

Designer: Amanda McDonald Key
Typeface: Futura Book, Futura condensed
Typesetter: LSU Press
Printer and binder: Palace Press International

Library of Congress Cataloging-in-Publication Data:

Barker, Claudia.

 Ya/Ya : Young New Orleans artists and their storytelling chairs, and how to Ya/Ya in your neighborhood / Claudia Barker.

 p. cm.

 ISBN 0-8071-2092-8

 1. Ya/Ya (Organization) 2. Afro-American art—Louisiana—New

Orleans. 3. Youth as artists—Louisiana—New Orleans. I. Title.

706' .0396073076335—dc20

 96-31548
 CIP

To my daughters, Camille Josephine Tucker and Lucy Rose Tucker, in whose generation

we place our trust and our hope for the future

CONTENTS

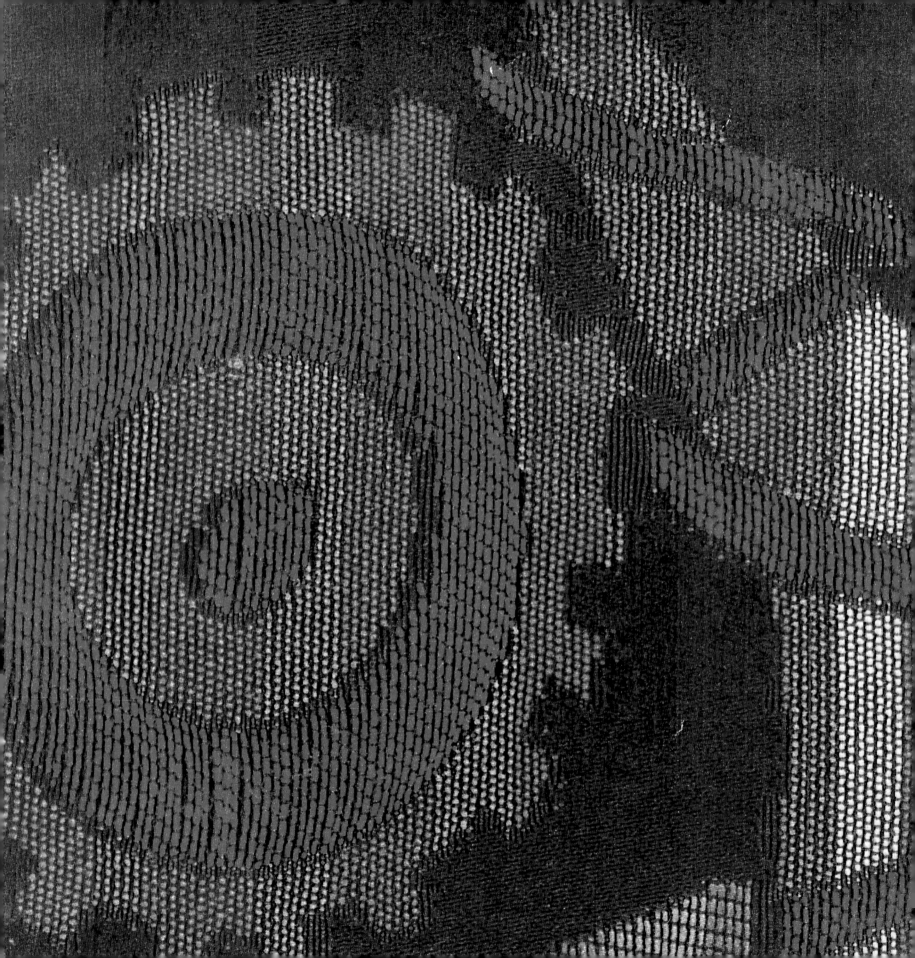

FOREWORD

I have visited YoungAspirations/Young Artists—YA/YA— at its home on Baronne Street in New Orleans. But even if I had never set foot on Baronne Street, chances are I would still have discovered this truly remarkable program. I would have heard of its success through the press, seen the work that it produces for offer through national catalogs, become familiar with its products through the marketing efforts of the international companies that it designs for, and certainly learned about it through arts-community lore, which holds YA/YA as a stellar example of how neighborhoods and lives are transformed through the arts.

What I might never have appreciated, though, had I not walked through the door of that building in downtown New Orleans, is the full power of the young aspirations that make it unique. Spirit, talent, and entrepreneurship are triumphantly present in this project that empowers youth to change their lives. They don't all become artists. But they all learn, through the arts, the skills needed to go out in the world and succeed: discipline, self-esteem, collaboration, and problem solving.

Claudia Barker provides a window into the house on Baronne Street. She witnessed the beginning, and she is a part of what made it happen. The story of Young Aspirations/Young Artists is one of optimism, determination, creativity, and hard work. It is expressed in the artwork and in the bright lives of the students who have been through the program. And it is told with vibrancy, clarity, and style in the pages of this book.

Jane Alexander
Chairman, National Endowment for the Arts

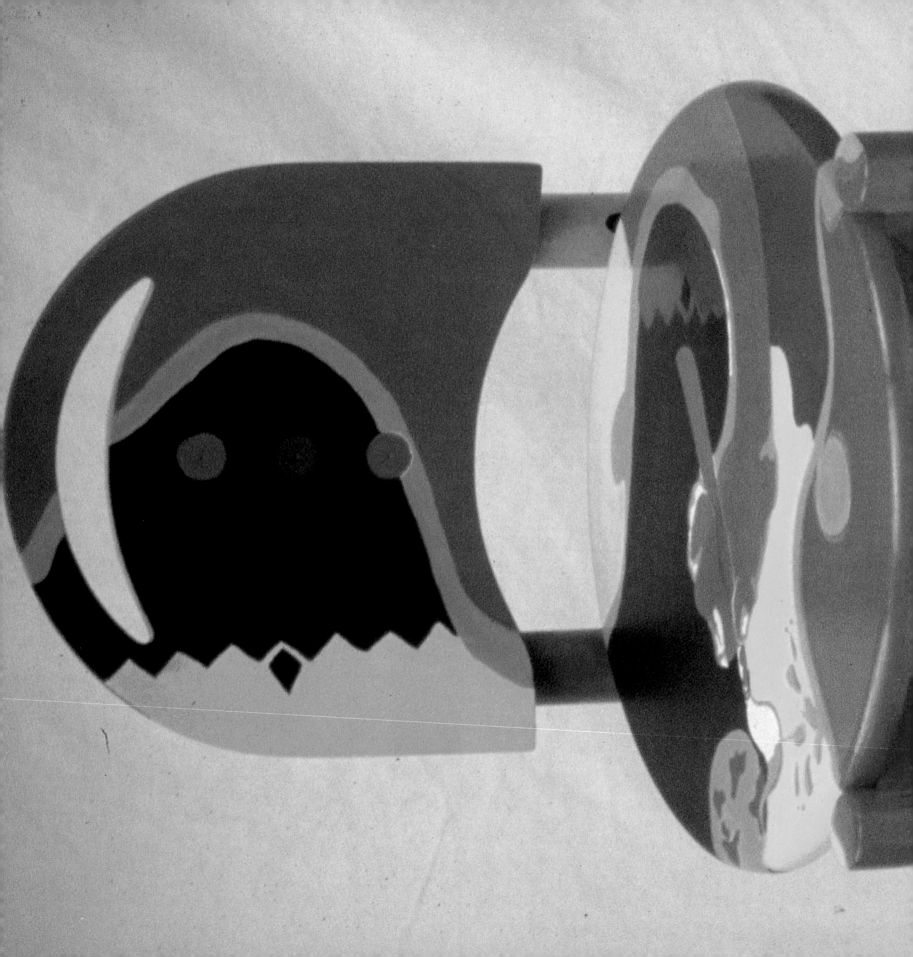

ACKNOWLEDGMENTS

This book was a labor of love. Many people helped it along, either out of affection for YA/YA or for me or some combination thereof. Foremost among them are the YA/YA students, who entrusted me with their memories and their feelings about being part of YA/YA. Standing with them is Jana Napoli, who created something worth documenting, something that merited the dedication of so many people—students, parents, staff members, and friends.

In particular I wish to thank Paulette Hurdlik of Design Partners; YA/YA artist Carlos Neville, who helped me and the publisher envision the book; the other YA/YAs who did the drawings used as graphics throughout the book; and Diana Pinckley, Doug Brinkley, Sid Jacobson, Skye Moody, and Marigny Dupuy, all of whom read the manuscript and made useful suggestions. YA/YA staff members Raj Dagstani, Rosemary Dennis, Jackie Dinwiddie, Steven Griffin, Madeleine Neske, and Ann Schnieders also reviewed the manuscript, as did YA/YA founder Jana Napoli and Print YA/YA director Terry Weldon. I am grateful to Walter Brock, former YA/YA

staff member, who helped coax memories out of the students, and to Suzanne Malone, who transcribed the interviews and offered encouragement while I wrote the story. YA/YA is fortunate to have had so many fine photographers document its students' work. Special thanks go to Michael P. Smith, who has donated his time and talent since YA/YA's earliest days. Ann Schnieders helped sort through and identify hundreds of images, making the process of final selection much easier than it might have been.

Many thanks are due the National Endowment for the Arts, especially Wendy Clark of what was formerly its Design Arts Program, and the trustees of the Mary Freeman Wisdom Foundation, who helped fund the creation of the book. Thanks also to Les Phillabaum, Gerry Anders, and Amanda McDonald Key, all of LSU Press, who made the book a reality.

Finally, I am deeply grateful to my husband, Michael Tucker, and to Jerry Daigle, for their wit, wisdom, and unfailing support of my efforts.

part I

YAK! (Sketch)

A WALK AROUND THE CORNER

"I just had been given this show in Lincoln Center, and I was supposed to do a public service." Jana Napoli, YA/YA's founder, is talking about the first exhibition of YA/YA painted furniture to travel, a show that also included work by Jana and several other professional artists from New Orleans. "I always felt guilty that I wasn't doing my part in the community, that there was lots of stuff that needed to be done and I wasn't doing my piece." After a brief stint working at a youth shelter in another neighborhood, she realized: "There are perfectly wonderful kids in my neighborhood that nobody's paying any attention to at all. What am I doing trucking across Rampart over there to do a public service?"

Spring, 1988. Jana walks around the corner to L. E. Rabouin Career Magnet High School and meets Dr. Carol Chance, Rabouin's principal, who can see the value of her students' working with a professional artist and supports the creation of a partnership with Jana's gallery. Dr. Chance leads Jana to Madeleine Neske, Rabouin's commercial-art teacher. Madeleine, a free-spirited career educator with a passion for

vocational education, is a natural ally for Jana. Together the two come up with the idea of having the Rabouin students draw pictures of downtown New Orleans buildings and show them in Jana's gallery. Maybe, they think, this will attract the buildings' owners and create some ties between the students and the community.

November 5, 1988. Thirty-five nervous, excited, dressed-up young people are looking up at their drawings, framed and hung on the walls of this lady's gallery. Their eyes dart from their pictures to the faces of their friends and families.

They watch as Jana introduces one boy to a man in a suit, who shakes his hand and points up to the drawing of a three-story building on Carondelet Street. The man is smiling broadly. The boy is smiling shyly, his

L. E. Rabouin High School, painting by Dick Malanobkix.
Courtesy Dr. Carol Chance; photo by Francine Judd

head tilted down, wondering if the man really likes the picture or if he's just being nice. Suddenly the boy realizes that the man is taking out his wallet, counting out the twenty-five dollars that the drawing costs, paying it to the girl who is taking the money. The boy glances from side to side to see who is watching. He feels a rumbling of excitement in his stomach. He can't believe it. He has just sold his first drawing.

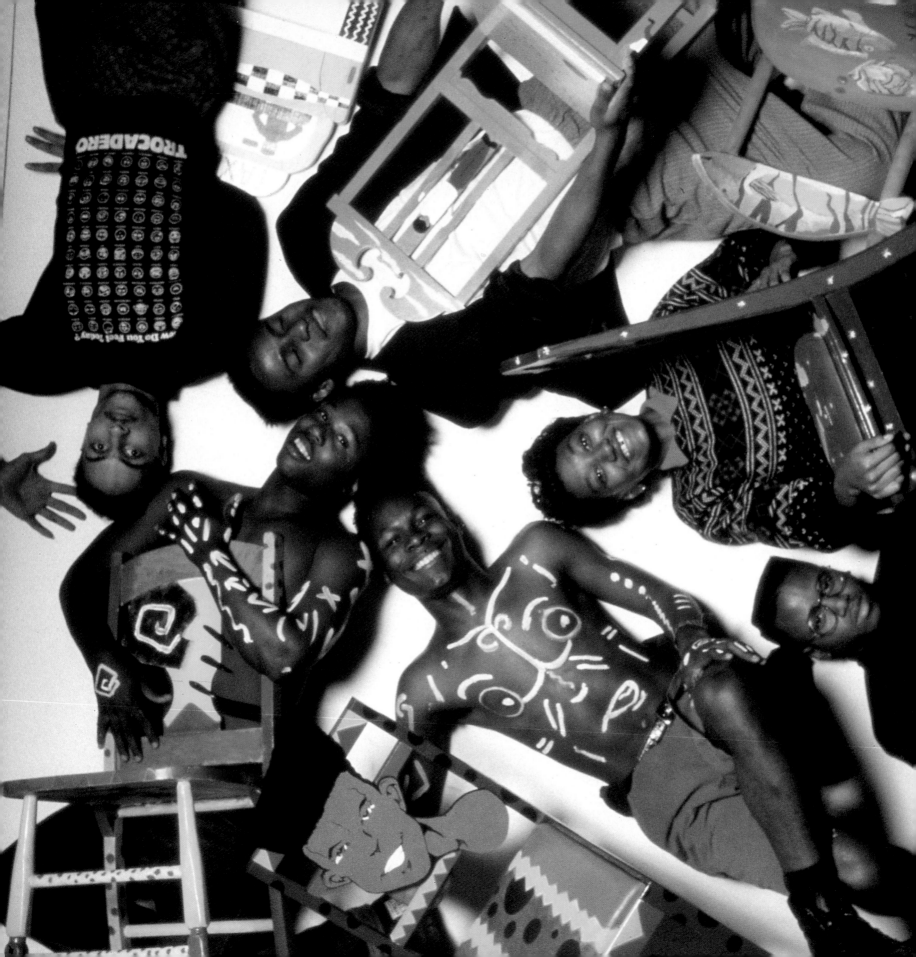

THE original

YA/YA is an acronym for "Young Aspirations/Young Artists." There is also a Yoruban word *ya-ya*, meaning "eldest daughter," and in New Orleans, the food capital of the South, the term has developed a colloquial meaning through the phrase "gumbo ya-ya," a rich local soup featuring sometimes seafood, sometimes meat, always vegetables and rice. So it fits, this odd-sounding name, on a variety of levels, to describe what Jana gave to her students. It means hope and art, food and family. It is local and international, Anglo and African. It is what the first eight YA/YA Guild members came to be called: the YA/YAs.

EIGHT

"My taxi cab, of standard American design, can take me around to see the world. People, seeing me in a cab, can't help but wave me down, so I'll catch a few customers along the way, too."

—Carlos Neville, 1989, twenty years old

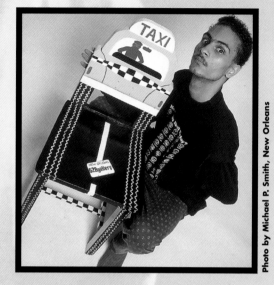

Carlos Neville and *Taxi Chair,* 1989.

CARLOS the clown. Break dancing and spinning on his head in the French Quarter for money and applause. Thin and wiry, Carlos can make his body collapse into a tight ball and spring open like a jackknife. His deep-set green eyes see a world that is a lot more whimsical than the one most of us see: A chair turns into a yellow cab. Cut-out sculptural flames leap from another chair, which Carlos has made into a burning building. He puts a wooden baseball cap on top of a baby chifforobe and big clown shoes on its bottom. It becomes a funny man, like Carlos, protecting private things that are inside with a comic exterior.

Hot Seat, **1993.**

BRYAN the cerebral. Sometimes brooding, but with a mischievous smile, he is the designer in the group who created YA/YA's logo. Smooth

talking and seemingly self-assured, Bryan McMillian is the elegant spider who weaves a silky web of sounds and words that almost compel

you to...give him $300 so he can buy his girlfriend's prom dress. Bryan could sell water to fish and make them think they got a great deal.

Gifted in interior design, he becomes YA/YA's expert marbleizer, enabling him to transform any dull hallway into an elegant eighteenth-century

foyer, adding the illusion of richness to any surface, any time.

"Action speaks louder than words and art speaks even louder! This is a sample of Lionelism, illustration stylist: the way I like my art to be projected. Oh yeah, Hi Mom!"

<div align="right">

—Lionel Milton, 1989, sixteen years old

</div>

Untitled, 1996.

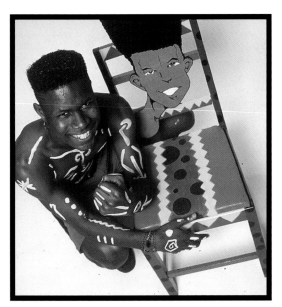

LIONEL the entrepreneur, the one who came in and said, "I want to study in Paris." And so he did. Part bad-boy cartoonist, part graphic artist, Lionel—"Elle-one" to his friends—creates designs that are fluid and flamboyant. The self-proclaimed "black sheep of YA/YA," he saunters into the place sporting black horned-rimmed glasses, a fluorescent smile, and low-riding jams down to his knees. His meticulously drawn peanut gallery of hip-hop characters has impressed the likes of Spike Lee and Magic Johnson. Perhaps most impressive, Lionel now is supporting himself and his wife and two children through his art.

Lionel Milton and *Vision of Myself,* 1990.

Photo by Michael P. Smith, New Orleans

"With simplicity I can identify the most complex. In all of my pieces I mix the mind with matter in the most simple form. I really hope that my artwork goes over well. I'd really like to see me and my friends go far in life with what we like. For me, Peace, Love and Happiness and freedom of expression to everyone. Let it be a way of life."

—Skip Boyd, 1989, eighteen years old

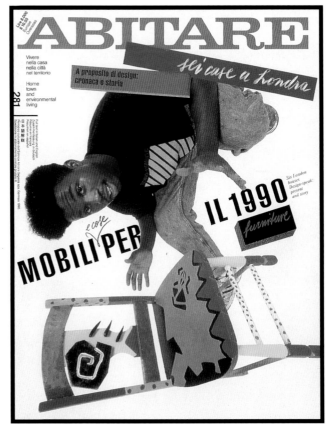

Magazine cover: Skip Boyd, 1990.
Photo by Michael P. Smith, New Orleans; courtesy *Abitare*

SKIP the opportunist. Yes to this, yes to that, yes, well, *maybe*, to everything. Big bold designs, explosive childlike movement. "Skip, come back here! Will you please, please finish this chair—the guy's coming to pick it up in an hour!" Boyish and ephemeral, Skip, also known as Daymein Persley Boyd, is as hard to hold on to as a splash of mercury. He blasts through the front door, chewing on an apple, throws his stuff on the floor, gives you a big kiss on the cheek, and sprawls in your chair.

Skip Boyd, Piero della Francesca Memorial chair, 1990. Photo by Michael P. Smith, New Orleans

"When I started drawing Boonchee, my dreams began to express the way I think about life. Boonchee is a little black girl that believes in her heavenly father who takes her on many journeys. She befriends all types of mankind and beautiful animals and sees wonderful places. She is full of peace and happiness. If everyone could race with a comet on a magic carpet and float in the air light as a feather through puffy cotton clouds, they would be happy, too."

—Darlene Marie Francis, 1989, eighteen years old

DARLENE the dreamer. A little girl on a magic carpet tours the universe, noticing everything, making stories, dreaming dreams. Her simple, homespun stories are written and illustrated with a childlike innocence, but their meanings are universal and profound. Darlene, and Boonchee, seem destined for fame. Most recently Darlene was selected to illustrate a book for the United States Department of Education entitled *Helping Your Child Learn to Read*. She and her artwork have appeared on *Sesame Street*, MTV, the *Today Show*, and Japanese

Darlene Francis, Boonchee chair, 1990, and (above) Boonchee chifforobe, 1992.
Photos by Michael P. Smith, New Orleans

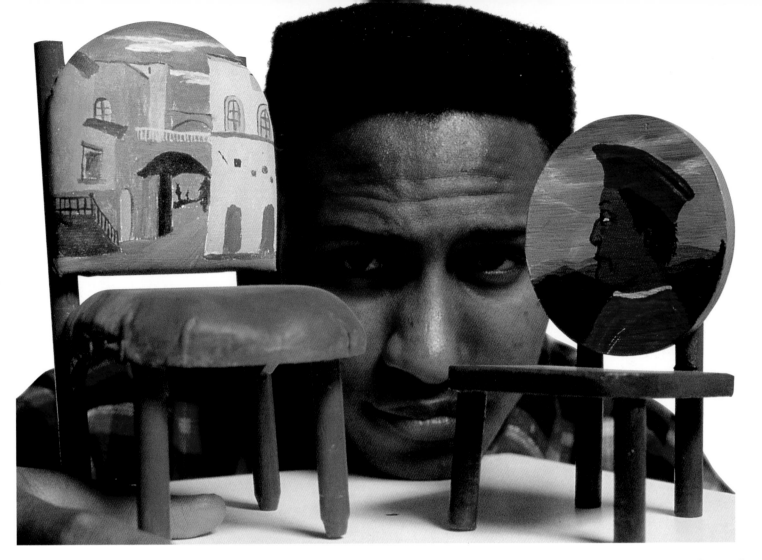

J. Dexter Stewart and his Italian minichairs, 1990. Photo by Michael P. Smith, New Orleans

"Art has been around for a long time. As far back as there is evidence of life, man has found art. Art marks a period of time and a way of life. Some of my art is inspired by events in my life, different moods, feelings, and music. Paintings and drawing are not the only forms of art I like. I admire all the arts: poetry, dance, and particularly music. I love to dream-up, draw and create."

—J. Dexter Stewart, 1989, twenty years old

DEXTER the photographer, the film maker, the one who sees an urban landscape and paints it on the round back of a chair, from an angle that is so surprising it makes you cry. Long asphalt roads divided by bright white lines figure prominently in Dexter's work, impressions of his life in the Big Apple (as a student at the School of Visual Arts) and his travels abroad. Often there's a dog or a lone human figure, looking dwarfed and vulnerable against a looming cityscape, an image of stark solitariness in a busy, big world that no one person can control. Dexter is now married, living in New York, and employed by MTV.

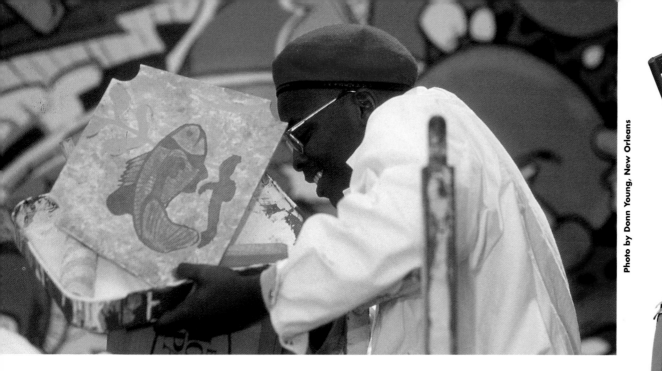

Photo by Donn Young, New Orleans

Fredrick Dennis'
fish chairs,
1992 and
(below) 1993.

Photo by Jana Napoli,
New Orleans

Photo by Michael P. Smith,
New Orleans

"I enjoy painting fish, but that's only because I like fish. The fish I have at home are called cichlids. They aren't always as colorful as certain tropical fish. My first fish chair was made because of a fish I had for four years that died. I like to collect baby fish. I'll have them longer and I like to see them grow."

—Fredrick Dennis, 1989, eighteen years old

BIG FRED, the strong and gentle spirit, the most painterly artist of the group, who loves animals. When asked to tell a story, he paints his pet fish that died. It is Fred, an imposing six foot two, two hundred plus pounds, whom Jana remembers joking about how white people would cross the street rather than cross his path: "I used to think it was really cool because Fred would come in and make jokes about it and I knew his feelings were hurt. I thought, what a great way to deal with being hurt." Colorful tropical fish, black-and-gray Gulf fish, graphic depictions of fish on various murals, these are Fred's signature pieces, all carefully researched, fed, tended, and loved by Big Fred, now studying painting at the Memphis College of Art.

"The true essence of painting chairs is simple to express. You look, then feel. Everything has a shape, personality, life, style, character. I take it as my responsibility to help the chair express itself. I don't find it hard because chairs are small. Don't think I'm saying it's easy. It takes time, but you learn to manage."

—Darryl White, 1989, eighteen years old

Darryl White, 1990.
Photo by Michael P. Smith, New Orleans

Darryl White, *Afro Man*, 1992. Photo by J. Dexter Stewart, New York

DARRYL, the musician, dancer, designer, and painter, who chose to study chemistry before committing to art. Feisty and droll as well as gifted, Darryl is the first YA/YA Guild member to finish college, earning a bachelor of arts degree from Xavier University in New Orleans in May 1995. Completely untrained in music, Darryl once sat down at a grand piano at the home of a Memphis philanthropist and gave a spontaneous concert by just playing what he heard in his head. Echoing his talents in a variety of disciplines, Darryl's main style of visual expression is collage—the blending of many different elements into one unique whole, that works, that sings, that inspires.

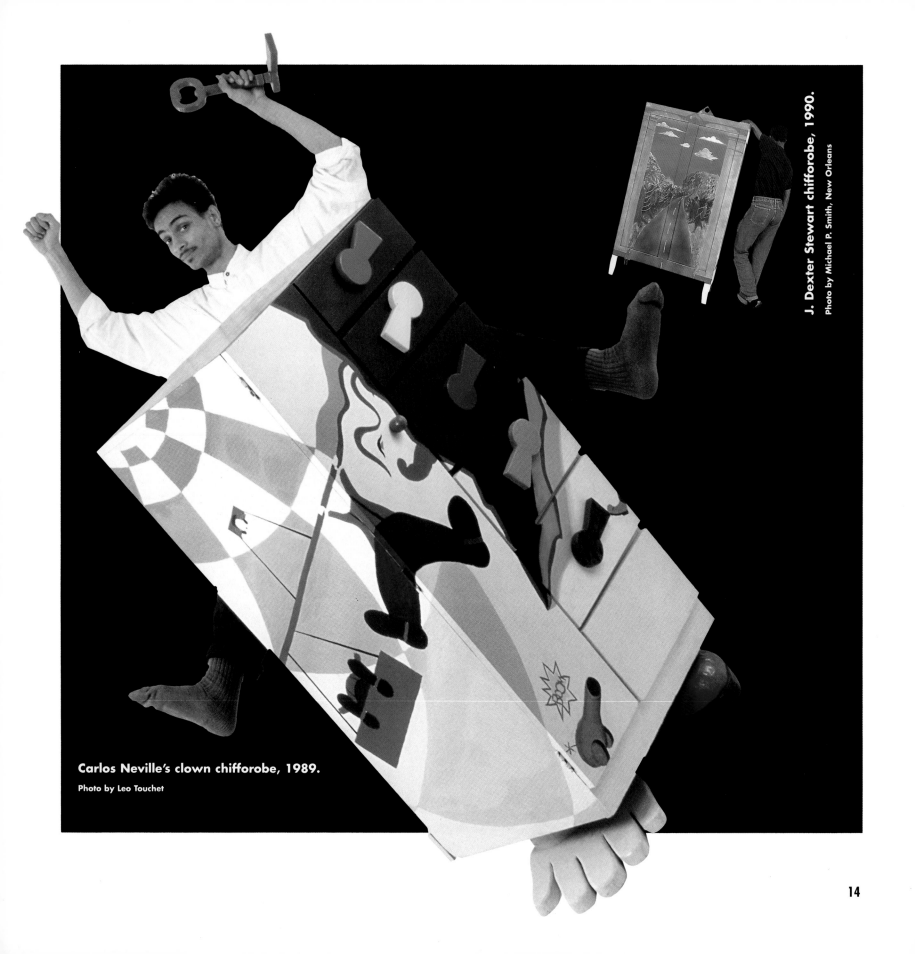

Carlos Neville's clown chifforobe, 1989.

Photo by Leo Touchet

14

The Chairs,
The Chifforobes

During the winter of 1988–1989 the YA/YAs begin priming and painting secondhand chairs, tables, and chifforobes. Jana is focused on the upcoming show in New York and comes up with a rhapsodic title for it: "Storytelling Chifforobes from New Orleans." The chifforobes are particularly effective vehicles for the YA/YAs' stories because their large flat surfaces seem to beg for imagery. Jana instructs the YA/YAs to paint their hopes and dreams on the outside and their fears on the inside.

The effect is electric. Carlos Neville sells his chifforobe to a collector on the plane to New York. He just happens to have a picture of it with him on the flight. A happy clown with big feet smiles on the outside. Inside are shadowy images of scary things— a sinister syringe, the devil, a giant cockroach.

After the first blush of shows and press, there emerge those eight special people who become the core group known as the YA/YA Guild. The Guild is based on the concept of the European crafts guilds, the first nonhereditary economic entities of the modern world, which were models of self-ownership. This is what Jana wants for the YA/YAs—access to a new and better system that will enable them to change the world. And the YA/YAs thought she just wanted them to paint furniture.

Darlene Francis remembers: "I'll never forget this. We was in Miss Neske's class, and I remember Miss Neske said, 'These are the names that I want to go over there to work at the gallery.' She called Bryan, Carlos...and then last she said me, and I was surprised. You know, everybody had left; she called their names, they got their booksacks, they went over there to the gallery, and they started looking at the chifforobes and picking out which ones they

J. Dexter Stewart and chifforobe, 1990.
Photo by Michael P. Smith, New Orleans

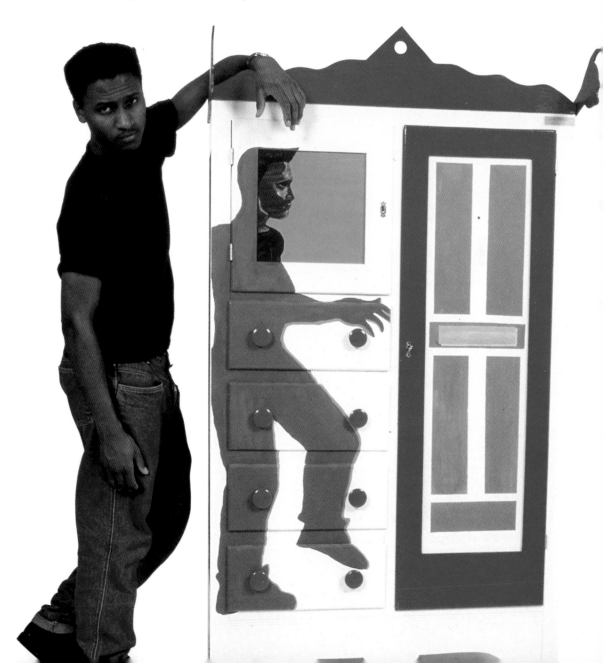

15

wanted. And I'll never forget Darryl was mad because she didn't call Darryl's name, and so sure enough Darryl fussed and complained and bickered, you know, and he got his way because he got his chifforobe and he started going over there, too. So that let me know that YA/YA was going to keep rolling. Plus she had started working on chairs—she said the next thing was chairs."

Chairs. The word is out. Chairs are it. They begin appearing out of nowhere, practically walking in off the street on their spindly legs, emerging sleepy-eyed from people's attics and garages. Old chairs, new chairs, red chairs, blue chairs, they all find their way into YA/YA, marching two by two, break dancing their way over the threshold, landing squarely on their backs, legs stretched out, ready to be primed.

What It's All About

How do we define success? Is it about making money? Is it a feeling? Is it progressing from one point to another?

A Friday, late at night. You have been working on your chair since three o'clock and Jana is telling you No, it's not balanced. See, right here, you need to put something green, maybe, or red to bring out what's on top. You're exhausted. The cold leftover pizza is sitting on the table in its cardboard box. Most of your friends have gone home. They finished their pieces. The show opens tomorrow. It's just you and Jana and one other YA/YA. This

isn't fun anymore. You want to go home. Finally, after much work, fighting, Jana scraping paint off of your chair with a razor blade, and you feeling frustrated and angry—finally, very late, when you are past tired and you think you can't paint another thing, maybe you don't ever want to paint anything again...that's when something magic happens. You let go and it leaps out, surprising you at first. You think Nah, this isn't any good, but your hand keeps painting and all of a sudden you see it, the thing you want to do and there it is.

At YA/YA success comes in many forms. It's the feeling you get when you watch someone stop, take two steps back, and stare at your artwork. It's what you hear when everyone is crowded around looking at a big article on YA/YA in a magazine. It is what happens when you sit a little wide-eyed kid on your lap and show him how to use a paintbrush so he can paint a mural in his classroom. Success means getting what we want—a commission, a job, a chance to travel—*knowing* what we want, helping someone to change, and growing up. Mostly, success is providing access to someone who might not have it—giving a talented person the chance to design the cover of a book, getting an internship for someone who deserves it, introducing a young person to someone who can help her get a scholarship.

But the real success, the most tangible, visible measure of YA/YA's success, is the YA/YAs themselves. When Eric Russell

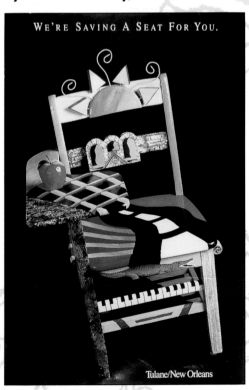

Darryl White chair on poster produced by Tulane University, 1992.

WE'RE SAVING A SEAT FOR YOU.

Tulane/New Orleans

came into YA/YA in 1990 he was a tall, lanky sixteen-year-old who made funny faces and rolled his eyes a lot. Five years later he is attending college, has produced his own rap demo tape, composed a tune for a musical Swatch watch, and serves on the YA/YA Committee, which makes key decisions about which students are offered opportunities for jobs and travel. His mother says she knew something significant had changed in him when she saw him walking through their home wearing a belt. "A belt?" she said. "Is that Eric?"

Part of it is YA/YA's demographics. YA/YA works with teenagers. And there is no more dynamic, ever-changing, vulnerable, powerful, in-your-face group of people on the planet than teenagers. The teenage years are the time when people learn about the world and try to carve their mark on it. It is the time when people ask questions: What do I want? What must I do to get it? Who am I and how do others see me? And the really thorny one: Am I good enough?

So when we see someone who has come through the YA/YA program go on to excel as an intern at Gallery 37 in Chicago, as Rondell Crier did, or create artwork for a poster for Tulane University's admissions department that wins national awards, as Darryl White did, we know what real success is. And it is on that and on them that we try to keep the focus.

March 1994. The YA/YAs are hard at work painting nine baby chairs that will be given to the winners of the Arts Council of New Orleans' Mayor's Arts Awards, bestowed for significant contributions to the arts in New Orleans, whether through creation or support. Each chair will be different, painted with images that mean something to the individual Arts Award recipients. YA/YA apprentice Kenyatta Johnson is painting a chair for Mrs. Francoise Richardson, who has done a great deal for the arts in New Orleans. Kenyatta, however, has never met Mrs. Richardson. She doesn't have a clue about what is important to her. She doesn't know what to paint. We start asking around. Who is Francoise Richardson? What does she like? Kenyatta learns that the lady has given some beautiful pieces of African art to the museum. We call the museum staff, and they send us pictures of the work: two standing female figures and one bronze mask that looks like a cat. Kenyatta cuts their shapes out of plywood and attaches them to the chair. She paints the voluptuous female figures in various shades of brown, their headdresses orange, yellow, and periwinkle blue. She paints the cat face chartreuse with some black and red markings. The figures add a lot to the chair, but it is not enough. We call a friend of Mrs. Richardson who tells us that the lady has a much-adored pet, a sheepdog. Kenyatta

Eric Russell baby chair and hand-painted ties, 1992.
Photo by Michael P. Smith, New Orleans

17

Kenyatta Johnson and her 1994 YA/YA Delgado Exhibition chair.

Photo by Jana Napoli, New Orleans

son, standing where the chairs are being displayed. She is looking at her chair, and she is glowing. We introduce her to Kenyatta. "Kenyatta?" she says carefully, wanting to get the name right. "I love my chair," she says in a soft southern voice that gives the word *chair* two syllables. Kenyatta's smile is a beam from within. The chair is a success. And so is she.

It is that element of the artwork, that piece that comes from something inside of you, that truly makes it interesting, that stands up and grabs people by the collar and makes them try to remember how much money is in their checking account and think, "Can I *buy* this?" When creativity manifests itself in an authentic way, the product is very compelling. It shows what is inside of the creator. It also shows something about the creator's world, his society, and what he has in common with others in that society.

Jana explains to the YA/YAs: "You have something inside of you that's hot, that attracts people, that's *you*. And if you find that, nobody can ever get ahead of you be-

looks up sheepdogs in the encyclopedia. There is a picture. We ask around some more, find out that the dog is gray and has a fluffy tail. Kenyatta paints Mrs. Richardson's sheepdog, on a beach at night, gazing up at a yellow moon. We all look at the chair. We think it will work.

Two weeks later, all the YA/YAs go to the awards luncheon. We see Mrs. Richard-

Kenyatta Johnson's Arts Award chair.

Photo by Michael P. Smith, New Orleans

18

cause you're always generating it. They can copy you, but they always copy what you did yesterday. That's why I came up with the story stuff. Give me a dream, something that nobody else could have had in their head. Anything—I didn't care where it came from, and I didn't care if you made something abstract out of it. But I wanted a *hot spot*."

Hot Spots

"My stories came from nowhere," Carlos says. "They didn't really mean anything. It had some insight, of course, but I didn't try to define it. And then later on you realize, oh, wow, this *does* have a meaning, I *did* get this from somewhere, this *did* come from something in my psyche, and I don't even worry about where it's coming from or what it means. And if somebody asks me, I'll make up something right there just to entertain them."

Chris Paratore wanted to do abstract chairs ("I ain't into no stories," he said). But Jana saw his gift and wanted him to do watercolors. Rondell Crier didn't want to paint a story on his first chair, so he came up with the idea to do a chair about his dog—only he didn't really want to do it. Jana didn't think it was very interesting either. So often in the beginning, student and teacher work at cross purposes: while Jana is trying to pull something meaningful out of the students, searching for a piece of their true selves, the students are trying desperately to paint something fun. Fun usually

translates into "decorative," and this is not what YA/YA was meant to be about.

Darlene Francis, the first female YA/YA Guild member, remembers how she felt doing her first piece: "In a way it felt kinda like you was naked...like you was puttin' your soul out there."

YA/YA artwork is successful because it mirrors its creators, it illustrates their thoughts and their feelings. It is full of "hot spots," personal imagery that is often intensely dramatic. When Dexter Stewart did his first chifforobe, he painted monsters on the inside of the drawers, waiting to leap out at him. A piece by Carlos Neville shows a boy being caught spray-painting graffiti by the police. On a minichair by Edwin Riley, a dark-skinned man carries a large crosslike object up a steep hill. These are the things that are hot, that are important to the YA/YAs. These are the things that define them personally. These are the things of which dreams are made.

Literally. Edwin Riley, one of the "second generation" YA/YA Guild members (the next group to come after the first eight), a quiet, sweet guy whose work ranges from abstract design to a chair with scary red *Nightmare on Elm Street* claws on it, has a dream and tells it to Jana. It is about fighting, about a black person beating up a white person. Jana sees the dream imagery and tells Edwin to paint it on a chair. Edwin remembers his discomfort in doing that. "I was telling her about my dream I had. She was like, I should paint

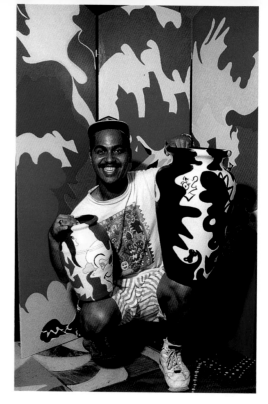

Chris Paratore with vases and screen, 1994.

Photo by J. Dexter Stewart, New York

that...do it with some soft colors and to try to hurry up because it was over the summer and we had to get ready for the show in October. After I got finished, I hated the chair. Every day I worked on it, I hated it more. I did. I didn't want people to think I was a racist person."

Strong feelings about our own personal stories ignite our creativity. When Jana told the YA/YAs to paint their hopes and dreams, she not only gave them an assignment, she gave them *permission* to search their souls for an experience and a set of feelings that could be made into art. It is that depth of feeling that makes the YA/YA work seem so vivid and alive. It is not just the vibrant colors, it is the joy, anger, sadness, fear, or peace that the person feels in his heart as he paints with them. The result is a piece of work that speaks to you, that walks up and taps you on the shoulder until you turn around. The result is something you can't ignore.

Fame (Some) and Fortune (a Little)

The exhibition held in March 1989 was the first official "YA/YA" show of painted furniture. The fact that the show was going

to New York gave it credibility. Walter Brock, YA/YA's administrator, remembers: "I have two friends that bought things in that first show because they came in and they felt some electricity was happening there. All the things that were going to go to New York were already marked as sold. So they walked in and my friend that bought Fred's first chair, she said, 'My God, I walked in and almost everything was sold. I was desperate.'"

Desperate to buy a piece of furniture by an unknown artist? This is the value of hype. This is what happens when the media makes it seem as if somebody, somewhere, is *very interested* in a product: everyone else wants it. Jana remembers, "I figured that the show in New York was it, that people were never going to buy us locally if they didn't think somebody else would want it. I thought out of town was the answer."

"The first summer we had one job, for sixty-five dollars," Jana says. "That's why I had the students paint the outside of the building." And paint it they did, with flat brown Egyptians carrying bags from McDonald's and golden arches that look like hieroglyphics. Black leopard spots on red background, elegantly marbleized frieze up above, a fish or two swimming in a deep blue ocean. The YA/YA building is advertisement. It's hard to miss.

Five years later we are being hired by Swatch to paint a thirty-foot-high fabric-covered chair in the court yard of a mu-

seum in Germany to advertise YA/YA–designed Swatch watches. Different YA/YAs, different images. But YA/YA all the way.

Commercial jobs are the vehicle to fame and fortune at YA/YA: They mean money and prestige. They mean exposure for the YA/YAs. They mean magazine and television coverage. They mean payment for services rendered. Different from making and then selling a piece of artwork, a commercial job, especially a large one, means a work for hire—and that means you've got to please that client.

November 1990. Four YA/YAs are sitting around a very large, shiny table in a fancy office downtown. Two women wearing business suits are looking at their sketches. "I think it would be better if the mural was a bit more historical," one of them says. "Our bosses want it to reflect the Old South with elements of New Orleans Mardi Gras culture added in." The YA/YAs cringe. One starts to explain the concept for the mural, a collage with caricatures of New Orleans faces, a Mardi Gras Indian in full regalia, a giant postcard written in New Orleans dialect. "Oh, no, that would never fly," comes the response. The YA/YA who wants to draw the postcard is starting to get mad. The YA/YAs and the women go back and forth, explanations, suggestions, everyone trying to be polite. After all, this is a job, the YA/YAs are thinking, we don't want to lose it. After all, these are budding artists, the women are thinking, we don't want to discourage

YA/YA set for WNOL *Do Something* telethon, 1995.

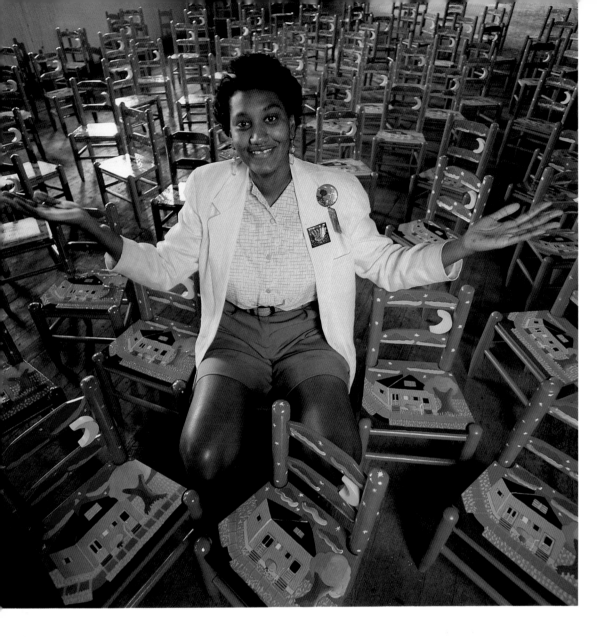

out a big job and then, boom! We have three jobs all due the same week. Everyone is scrambling. Jana is pushing the YA/YAs like a herd of cattle. We schedule people to work mornings and evenings. This means more staff time, but it also means more money coming in. So we do it.

Sometimes we really get in over our heads. Like when Hammacher-Schlemmer, the famous best-of-the-best catalog, asks us to produce 150 children's chairs. No problem, we say to them. How in the world are we going to do that? we say to ourselves. We submit several different designs. Darlene Francis' *241 South White Street* is selected, and groups of students start priming and painting. The idea is for Darlene to make a stencil so that other YA/YAs can help "mass-produce" the chairs on the second floor of an old warehouse on Poydras Street that has been lent to us for big jobs and storage. The reality is that nobody but Darlene can put the final touches on the pieces. She goes over each and every one of them before they are boxed and shipped out.

Darlene Francis and her *241 South White Street* baby chairs, 1992.

Photo by Michael P. Smith, New Orleans

YA/YAs in TV Land

MTV offers YA/YA one of the most interesting design jobs we've ever had: the YA/YAs are to paint 1,600 wooden desk ornaments in the shape of the MTV logo— and paint each one differently. The miniature sculptures are to be given out to MTV's clients and friends in honor of its tenth anniversary. A great exercise in design, the

them. Gradually there is a compromise. We throw in a steamboat. The YA/YAs have negotiated their first big contract.

After that first slim summer, commercial jobs begin to come to YA/YA on a regular basis. Maybe *regular* is the wrong word. We might go for a couple of months with-

job keeps YA/YA's newest recruits busy during the summer when the first- and second-generation YA/YAs go to Europe. Tables and tables of M's stand in the gallery. M's in progress. M's approved. M's varnished and ready to go. The folks at MTV love them and feature them in their slick tenth-anniversary publication.

The Bravo Cable Network gives us one of our most varied commercial jobs, one that stretches the YA/YAs to do more than just visual art. Bravo contracts with YA/YA to participate in its trade shows. The deal is that three or four YA/YAs work the Bravo booth, painting chairs and exhibiting their artwork to demonstrate Bravo's involvement in and support of the arts. A cultural cable channel, Bravo wants to entice more cable operators to pick up its service and offer it to clients in more cities. While some cable companies strategically position a tall slim woman (or a giant plastic dinosaur, depending on the network's type of programming) to lure potential clients to their booths, Bravo features the YA/YAs, doing what they do best and talking to whoever stops by.

"But Can They Dance?"

A similar job comes from the Canon camera company. But this time the YA/YAs get to travel to Paris to do it. And this time they not only have to paint, they have to perform. Dexter, Carlos, Darryl, and Lionel create a sort of visual tableau, performing for fifteen minutes out of every hour, being hip,

hot, American teenagers in action on stage. Canon pays YA/YA a small fee and the YA/YAs get paid for their time in Paris "doing YA/YA" for Canon.

Paint That Bus

When representatives of the University of New Orleans approach YA/YA to design a poster for the "Majic Bus," we're not really sure what it is. We quickly learn that it is a kind of magical history tour of the United States, with eighteen students traveling through forty states, devouring books, soaking up ambiance, and meeting the writers and artists who are shaping America's contemporary culture. Carlos Neville says to the UNO people, "Oh, wow, wouldn't it be great if we could *paint* the bus!" They tell him that the job will be done by a graphic designer. Within a few days Jana spies two young people peeking into the window of the YA/YA gallery at eleven o'clock at night. They look okay, so she invites them in. She discovers that one of them is Professor Doug Brinkley, the brains behind the Majic Bus, a free-thinking, high-energy educator with a keen eye for the media. Doug boasts that the specially equipped bus, which runs on natural gas, will travel "clean across America" in a combination educational exchange and media blitz that will benefit everyone involved. He wants YA/YA to paint the outside of the bus with images as diverse as Mount Rushmore and the Golden Gate Bridge. What's more, he wants to celebrate YA/YA's involvement by

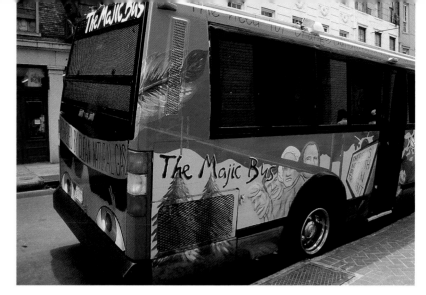

publicly thanking the YA/YAs and using them in the promotion for the bus tour. It is the best kind of commercial job: YA/YA gives, gets involved, gets thanked, and gets paid. The YA/YAs learn about history, combine it with funny, cartoonlike images, create a great collage design for the bus, earn money, and get to ride in a promotional parade that culminates in a gospel

Majic Bus, 1994.

Photos by Michael P. Smith, New Orleans

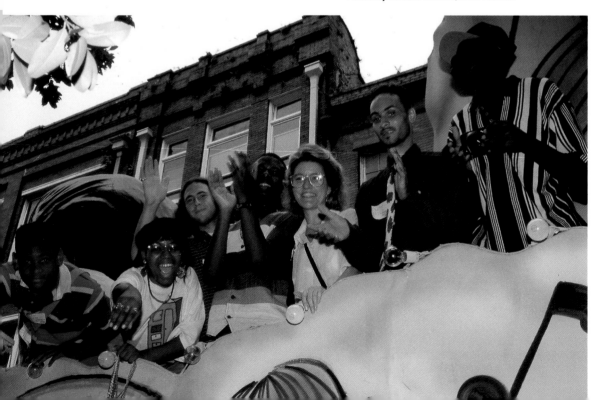

brunch at the House of Blues.

September 1992. A fifteen-year-old girl comes to YA/YA because Ms. Neske, her art teacher at Rabouin, thinks she is talented. The girl is shy and afraid—everyone else seems to have been there so long, and she doesn't know where she fits in. She doesn't know what to paint. Everything she tries comes out with too much black in it. Her parents come to the first show she is in, but her piece does not sell.

She keeps coming. She makes a friend, a girl who has been in YA/YA for about six months. They talk and laugh while they're painting. The other girl paints beautiful flowers with rich textures and lots of detail. The new girl tries to do this, but what she really wants to paint is houses. Purple ones with green hills, a black picket fence. A storm approaching. So she does.

A year later her work is in a show in San Francisco. Her chair sells! And the lady who buys it wants to commission another one! She feels great. She feels confident and happy. She feels she belongs.

YA/YA hopes that by the time a YA/YA graduates from high school, his or her artwork will sell quickly off the gallery floor and will be sought out by customers who want to commission something special. Usually, by this time the person's skills are good enough that he or she may be hired to do other kinds of art jobs, like designing a mural or teaching younger children.

YA/YA's development parallels that of the young people it serves. As YA/YA

grows up it attracts better and better contract jobs, like designing walls, furniture, and flooring for the corporate lunchroom at Blumenthal Print Works or, more recently, designing watches for the Swatch corporation—a far cry from the first summer when all YA/YA had was one sixty-five-dollar job. YA/YA has also begun to employ some YA/YAs as production and administrative interns, which gives them the opportunity to earn regular wages and gain experience. From all of this the YA/YAs begin to learn that there are lots of ways to make money—an important piece of information to have for someone just starting out.

Stirrings on the Home Front

Fall, 1994. New Orleans is like a sleeping giant, stretching its arms and legs, preparing to wake up and smell the café au lait. The economy, which has been in a slump for almost ten years since the oil bust, is slowly beginning to revive. For better or worse, the state legislature has managed to approve the onslaught of casino gambling, despite the fact that the state constitution forbids it (a mere detail), and everyone is poised to make big money off of an activity that ranges in spirit from recreation to addiction. The tourist industry has finally gotten its act together, and the hotels are beginning to show higher occupancy rates. Even unemployment is down a bit. Lots of people are studying to become card dealers. The art gallery next door to YA/YA moves deeper into the warehouse district

and is replaced by a school for would-be croupiers. A sign of the times.

Another sign of the times is the public's impatience with bad government as usual. Many New Orleanians are angry that something as radical as legalized gambling has been imposed on them without even the benefit of a public vote. A reformist school board gets itself elected and starts working to improve public education. Investigative reports on everything from insurance scams to the poor conditions in the city's public schools jam the airwaves. A bar owner on Decatur Street posts a daily body count of violent deaths in the city, heightening awareness and making people angry. To those of us who have lived here all our lives, it feels as if people are getting ready to pay attention and maybe even take some action.

One loud and clear action is the election of a no-nonsense young African American crusader as the city's new mayor. He runs on a platform of cleaning up the inner city, combating juvenile crime, and beefing up the police force. He spends the night in a housing project a few days before the election, he talks to everyone who wants to talk to him, he almost compulsively takes the pulse of the city on a daily basis. As soon as he is elected he imposes a strict curfew for people under eighteen. And then he turns around and hires the YA/YAs to design and paint the entrance to his transition office space.

The new mayor wants images of his

YA/YA mural at New Orleans Centre, 1991, with Darlene Francis (above) and Fredrick Dennis (below right) painting their sections.

Photos by Donn Young, New Orleans

New Orleans mayor Marc Morial (left) and YA/YAs, 1995.

Photo by Michael P. Smith, New Orleans

"Gumbo Coalition," a reference to the local soup made of many different ingredients. He wishes to include a gumbo ya-ya of New Orleans residents in the big job of city revitalization. In public speaking he not only gathers information about what the people want, but he also makes clear suggestions about how they can help themselves and help him do the job they elected him to do.

The YA/YAs work with the new mayor's staff to create images that represent his vision of the communal effort that will be necessary to make New Orleans a better place to live. They paint two canvas backdrops of people's faces in a bowl of soup, a cityscape with the Crescent City twin spans crossing the Mississippi River, sprinkled with crawfish, red, hot chili peppers,

okra, and a spoon to eat it with. The hip new mayor likes the YA/YA's work. He is pictured in full color on the cover of *Gambit,* the local alternative weekly newspaper, sitting in a YA/YA chair, his foot resting on an old-style tapestry-covered sofa. The new mayor—and the YA/YAs—are working toward the same goal: changing the face of old New Orleans.

A Job of Global Proportions

It starts with a phone call in the summer of 1993. Someone at the Swatch corporation has seen an article about YA/YA in a Danish magazine. She wants more information. Just an inquiry—but it starts an interchange that results in the YA/YAs being given the opportunity to design three watches for Swatch for its 1995 collection.

Between the initial contact and the signing of a contract, much happens. Jana pursues Swatch with the determination of a hungry fox onto a strong scent. Ideas bounce back and forth across the Atlantic, ranging from having the YA/YAs help design showrooms for Swatch to the possibility of Swatch offering internships for YA/YA

students. Jana goes to Milan, where the Swatch lab is located. She discovers that Swatch works closely with Alessandro Mendini, the famous Italian designer, for whom YA/YA students coincidentally had designed a vase during YA/YA's first summer abroad in 1990. Mr. Mendini suggests that YA/YA be allowed to try its collective hand at designing for Swatch. And how did Mendini first hear about YA/YA? He read about it in *Abitare,* an Italian style magazine, fourteen months after YA/YA was founded—before YA/YA even had very much to show for itself. But what it did have, it had good pictures of, and a couple of other major magazine articles touting it, too. Once again, good press opens the door for YA/YA. This time it is a very big door. And Jana, pulling the YA/YAs along, scampers through the crack.

August 1994. Jana is in Atlanta, meeting with officials from Swatch, finishing up business on the two watches YA/YA designed for the company. The watches are scheduled to be launched on February 1, 1995. The design process was a long one in which the

YA/YAs learned a great deal about pleasing a corporate client, about how big corporations work, and about negotiating good contracts. Jana is standing in the lobby of a hotel in Atlanta talking to Nick Hayek Jr., son of the Swiss-Lebanese man credited with revitalizing the Swiss watch industry in the 1980s.

Nick Hayek Jr. is in charge of marketing for Swatch, one of his father's most successful ventures. He is young, full of ideas, and eager to see Swatch get the most for its sponsorship of the upcoming commemoration of the fiftieth anniversary of the United Nations. Although Swatch is a medium-sized player in the corporate sponsorship game for the anniversary, the company could garner a big share of the media attention because of its colorful product and its youngish, hip clientele. Mr. Hayek Jr. has been talking to Jana about how YA/YA could help Swatch commemorate the anniversary. He is looking for an angle, a bold one that will lend itself to photo opportunities and make Swatch's contribution to the historic event highly visible. Since YA/YA is internationally known

UN fiftieth-anniversary appliqués by (top to bottom) Rondell Crier, Eric Russell, and Tarrie Alexis.
Photos by Michael P. Smith, New Orleans

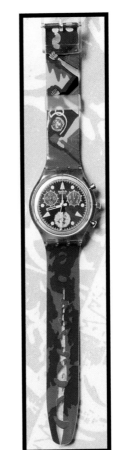

YA/YA UN50 Swatch, 1995.
Photo by Michael P. Smith, New Orleans

for its painted chairs, he decides that YA/YA should hand-paint fabric to cover the chairs in the historic General Assembly Room, the place where the UN delegates gather to make decisions of global significance. He is very pleased and surprised when Jana tells him that YA/YA not only paints chairs, but since 1993 has been hand-screening fabric as well.

It is an omen, a perfect match. Swatch and YA/YA begin the uphill battle to get the United Nations to approve the project, a task almost as delicate and complex as negotiating a cease-fire among warring nations.

In the meantime, the YA/YAs get ready to think globally, pondering possible themes for the fabric design. Mr. Hayek Jr. decides that YA/YA should design a watch to go along with the fabric.

Swatch's lead time on producing watches is even longer than what will be needed for fabric, so for the moment the focus changes to watch design. The YA/YAs begin sketching. At the end of August, we all go to the beach, where, at night, Jana makes everyone watch Bill Moyers' PBS series *The Power of Myth,* featuring the work of Joseph Campbell. Images and ideas from lost civilizations, gods and goddesses, good and evil—the YA/YAs squirm through three thousand years of humankind's attempts to figure out the mysteries of creation, existence, and spirituality through our own creativity. It is heady stuff.

We go home and the YA/YAs start making their own images of these big themes for the UN watch. YA/YA Brandon Thomas says, "I didn't know

UN appliqués by (top right) Tarrie Alexis, (top left) Sharika Mahdi, (middle) Blondel Joseph, and (bottom) Carlos Neville.

Photos by Michael P. Smith, New Orleans

28

they had a United Nations." Everyone draws. There are graphic images of the continents, painterly pictures of people from different lands, bold political images of unborn children. And there is the dove, the symbol of peace.

Most of the YA/YAs submit designs for the watch. Swatch combines two designs, created by different people, to make the watch.

On March 26, 1995, the New York *Times* reports, "This month, to celebrate the 50th Anniversary of the United Nations, Swatch issued a chronograph embellished with symbols of world peace and racial understanding. The watch's plastic band is emblazoned with images of locked arms of different colors and a ravaged world being sewn together; sections of the band are transparent so the color of the wearer's skin becomes part of the design. The watch was conceived by young artists who are members of YA/YA, a nonprofit arts organization in New Orleans."

One band of the watch, a multicolored locked-arm design, is the creation of Eric Russell, twenty. He says, "I was thinking about unity, and I had different colors to represent different nationalities and different races. I made them hold hands like they had accomplished a specific goal." Tarrie Alexis, the eighteen-year-old YA/YA Guild

UN General Assemby Room slipcovered by YA/YA, 1995.

Photo by Phillip Ennis for Swatch, Ltd.

29

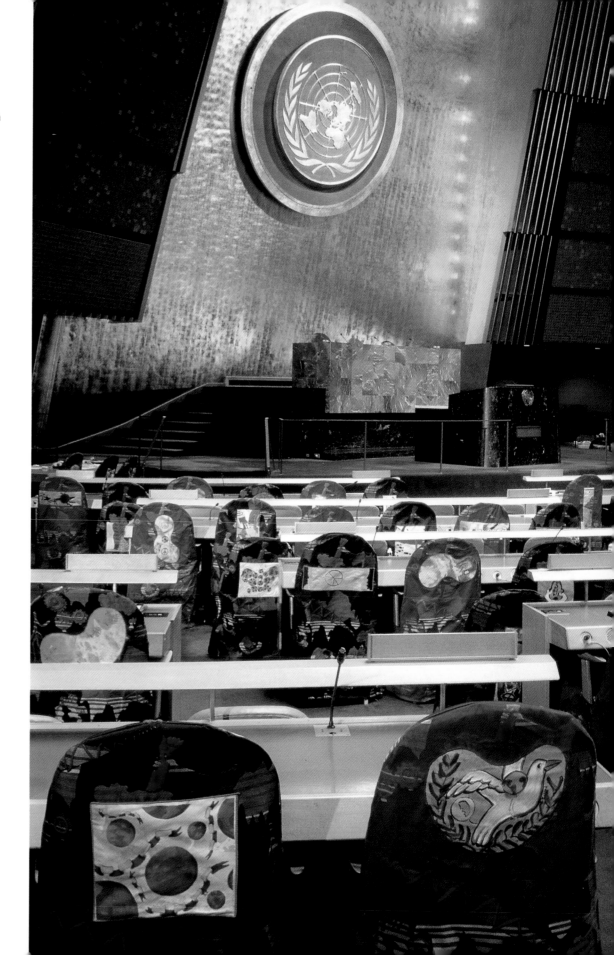

member whose image of the world being sewn up adorns the other band of the watch, talks about the creative process: "I just wanted to have a concept of bringing everything closer together. I mean, I put buttons on there first, but that looked dumb. And I put a zipper on there, and that looked dumb. And so...I was just looking down and I saw those stitches."

While the YA/YAs are hard at work submitting designs for the watch, from which Tarrie's and Eric's are chosen, the novel idea of having the YA/YAs slipcover the General Assembly Room lumbers up one channel to another in the very hierarchical, extremely political arena of the United Nations. Finally, in mid-December, YA/YA gets word from Swatch that Mr. Boutros Boutros-Ghali himself, the secretary-general of the UN, has approved the concept. Now all YA/YA has to do is design the fabric, manufacture it, sew the slipcovers, install them on the 582 chairs in the General Assembly Room, and show up for the fanfare.

The Swatch executives visit YA/YA two weeks before Christmas. They are very excited about the slipcovers. They are brimming with creative ideas. Why not have each chair in the General Assembly Room individualized in some way? Why not hand-paint them so that each one is different from the one next to it? Why not? And why not invite other young artists from

YA/YA fabric for UN anniversary.

around the world to collaborate with the YA/YAs in creating the global images that will adorn the chairs?

Why not? Because it's December 12 and the launch of the UN watch and the Swatch media event are scheduled for March 1! That's why not. The fabric must be designed, the design approved and refined, the fabric woven by a manufacturer and made into slipcovers, all 582 of which must be individualized in some way, and then they must be installed. What are the chances that we can pull this off? Slim and none, by my estimates.

We do it anyway.

Jana plunges into the job with both feet, both hands, and heart pumping wildly. She and Nick Hayek Jr. have chosen the twin themes of trust and fairness—concepts that affect young people of all nations on levels from the global and political to the private and personal. A brainstorming session with Swatch and YA/YA staff produces the idea of doing hand-painted appliqués based on these themes; the appliqués can be painted right away and sewn onto the slipcovers later. Everyone jumps into action. I begin creating a proposal and budget and negotiating the contract with Swatch. Ann Schnieders, YA/YA's administrative coordinator, manages to find and make travel arrangements for seven young artists from different countries who are interested in coming to YA/YA to collaborate on the job over the Christmas break. Jana makes plans to feed and house the visitors. Other staff

members agree to give up their Christmas vacation (we were scheduled to be closed between Christmas and New Year's) and pitch in to help: Raj Dagstani, production manager; Jackie Dinwiddie, bookkeeper and receptionist; Rosemary Dennis, operations coordinator. Conrad Lee, a visiting friend of Jana's, agrees to share his culinary talents with the group so that they may be fueled to work around the clock.

The YA/YAs begin designing the fabric, which Swatch dictates must include the images from the watch. Dozens of faxes shoot back and forth between Switzerland and New Orleans, outlining details of a very labor-intensive effort. Jana and I call on Harry Blumenthal, an upholstery manufacturer and YA/YA sponsor whose corporate headquarters are in New Orleans. We ask if it is possible to weave three thousand yards of very unusual upholstery fabric within a very short period of time. He says yes.

The design process is now in full swing. Terry Weldon, creative director of Print YA/YA, our fabric-printing workshop, begins working with the YA/YAs and the people at Blumenthal Print Works to help shape a collage of images that will work as a "repeat" on the woven yardage. There are video conference calls and more faxes. Jana, Terry, and a team of YA/YA Guild members create a series of mock-ups and begin the long process of trying to get designs approved by Swatch. Swatch begins the long process of trying to get designs ap-

proved by the United Nations.

Meanwhile, the visiting artists arrive. They represent seven different nations, very diverse peoples: Haiti, France, Switzerland, China, Russia, Colombia, and the San Juan Pueblo in New Mexico. The YA/YAs work day and night with the guests the week between Christmas and New Year's, hand-painting the appliqués that will be sewn onto the backs of the slipcovers.

It is an extraordinary collaboration. YA/YA Guild member Ron Ratliff comments, "I don't know if not speaking my language really mattered. They were able to come over here from different states and still feel like they are a part of us." Tarrie Alexis says, "We had stuff that was in common. Every night somebody would play some kind of music that they had. They were able to like some of our music." Of the artwork they produced, Charles Cooper says, "What everybody did represents their background and where they come from."

Tarrie Alexis talks about the diversity of artistic styles that emerged from the collaboration. "The thing I liked about working with all those people is that all their styles were different and what they had to say was different but that you got together to critique everything and that we were able to accept their style and what they liked and they were able to accept what we liked." Edwin Riley appreciates the connections with other artists: "I was in it because I just wanted to work with them. That's all—just to meet people from different places."

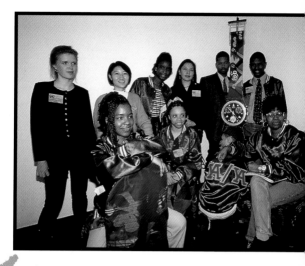

YA/YAs and international-artist collaborators, 1995.

Photo by Mario Morgado; courtesy Swatch, Ltd.

31

Together the YA/YAs and their guests create nearly six hundred small paintings, some representational, some abstract, all based on the themes of trust and fairness, all different, each one unique. Raj Dagstani counts and sorts the appliqués and ships them to seamsters in Maine and New York who will sew them onto the slipcovers.

January 1995. The Blumenthal mill in South Carolina sends us samples of woven fabric. Swatch insists that the colors be brighter. Blumenthal dyes yarn to please them. Then there is a problem translating the design via computer to the looms. Jana flies to North Carolina to consult with the computer experts and then hand-delivers the disc to the mill in South Carolina, where she works with the weavers to make sure that what the YA/YAs envisioned is what comes out on the fabric. After fifteen hundred yards are run, Swatch decides it wants another color change. The mill dyes more yarn, reruns the fabric. Jana and Ann are on the phone constantly, soothing various subcontractors, urging them to push to meet the deadline.

Then one day we have five or six different strikes of fabric spread out on the table at YA/YA. The colors and weaves vary a bit, but the images and the message are the same on all: Look what young people can do if given the chance.

Shazell Johnson talks about her image that becomes part of the fabric. "It is a sil-houette of a girl child with two Afro-puffs in her hair. She's happy, jolly, excited because she never thought she would be on fabric that would be so important. She's saying kids should be more recognized and have more opportunities and chances, that this shouldn't just stop here with YA/YA, this shouldn't just fade away. We should try to help more kids to succeed... help them live their dreams." She speaks of the collaborative nature of the project: "It was wonderful combining each other's images to weave the fabric. It's like weaving part of our souls together, combining them into a piece that will never be taken apart."

Rondell Crier comments on the symbolic significance of the whole collaboration: the appliqués, the woven fabric, the magic that happened when the YA/YAs worked with the visiting artists: "It's like we stitched ourselves together for the rest of our lives. Although it's unlikely that this special group of people will collaborate again in just this way, having the appliqués on the back of the fabric makes it so a part of them will always be with us."

Thirteen YA/YAs travel to New York on Mardi Gras Eve and spend the next day installing the slipcovers on the General Assembly Room chairs. Six of the foreign student artists join them in New York to celebrate the success of their collaboration and cement their friendships. On March 1, Shazell Johnson and Carlos Neville represent YA/YA alongside Jana at a Swatch press conference attended by journalists

Rondell Crier sketch for UN Swatch dial, 1994.

from all over the world. Mr. Nick Hayek Sr. says that the future of humanity lies in the spirit of youth. He speaks about the United Nations and the need for global unity in this time of unrest. The journalists are scribbling furiously, taking notes so they can write and spread the message to the adults who run the world. But the YA/YAs are smiling quietly, feeling the warmth of recognition and the knowledge that they are already well on their way down that road.

Brandon Thomas' UN appliqué.

Photo by Michael P. Smith, New Orleans

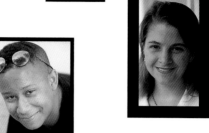

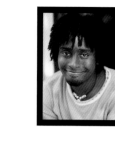

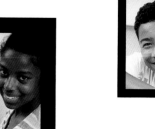

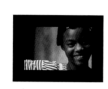

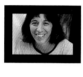

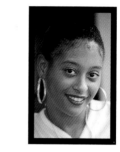
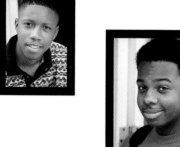
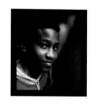

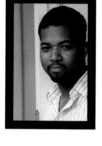
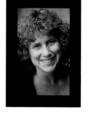

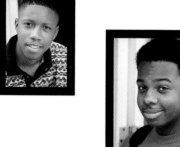

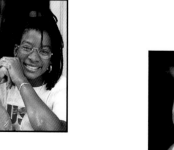

Photos by Missy Bowen

Everyone involved with YA/YA has a different set of images of what happened—how the magic of YA/YA came about and what it means to them personally. Therefore YA/YA's history is rich and varied, the stories have many slants depending on who is telling them, and in a way, they are all true.

ENVIRONMENT

EW ORLEANS, 1987. A sultry, sexy, southern city with a great deal of charm, a balmy climate, wonderful food, beautiful music, and one of the worst public school systems in the country. The lack of quality education tells on us: every couple of months the *Times-Picayune* informs us that we're "first" again—in the number of murders per capita, in the number of high-school dropouts, in the percentage of children living in poverty.

YA/YA, an arts and social service organization that trains young people in the visual arts, was founded by New Orleans painter Jana Napoli. "I never intended to start an organization," she says and admits to knowing nothing about how to run one. But for a long time she had noticed the throng of high-energy kids that emerged every afternoon from L. E. Rabouin Career Magnet High School around the corner from her building, and she wanted to find a way to put them to work. In addition, she wanted to bring the students, most of them African American, together with the property owners, most of them white, in her neighborhood.

Times were tough in New Orleans. A downturn in the oil and gas industries in the mid-1980s led to the exodus of thousands of taxpaying citizens and a deep recession that affected every level of employment. There were virtually no jobs, and particularly no jobs for young people with little work experience.

Students who attended Rabouin High School, the only school in New Orleans' central business district, were, like most people their age, perceived by adults as having limited skills and little to offer employers—at best. At worst, these young people were seen as potential troublemakers by the property owners who flank the school, especially when they emerged en masse at three o'clock and pushed their way like a storm front to Canal Street and the video game room. Their sheer numbers and volume caused most people to cross the street to avoid them, without even thinking about how doing this made the students feel.

And they did feel. YA/YA Guild member Rondell Crier says, "I'd get mad at them and I'd think...I'm not going to do them nothing, but they just don't know." He thinks about it and then adds, "I stopped getting mad because I'm doing it too sometimes. You walk down the street

Lionel Milton (left) and "Skip" Boyd, 1990

Photo by Michael P. Smith, New Orleans

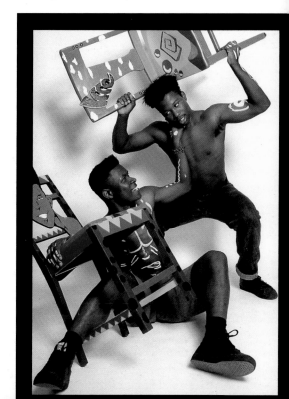

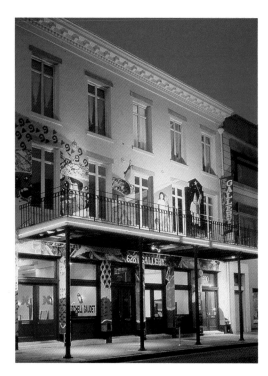

YA/YA building, Baronne Street, New Orleans.

Photo by W. H. Rogers III, New York

and you see a whole bunch of big old dudes walking down the street..." And you get scared, too.

These teenagers—like most teenagers—are incredibly energetic, very quick-minded, perceptive, and resourceful. They are physically strong and they see and hear well. Ancient societies knew the value of young people and used them as scouts and runners, to gather and convey information. People who lived in preindustrial times put their safety in the hands of sharp-eyed, sure-footed youth, whose job it was to protect and to serve their communities. In our world, however, and particularly in this American society and this southern urban community, these very talented, capable individuals are almost all unemployed.

It is three o'clock in the afternoon. School is ending and the students who attend Rabouin, a vocational-technical high school, are like wound-up springs. They blast out of the school building, pent-up energy exploding in all directions. Ready...set...*wait a minute!* Where to go? What to do? Shopping? No money. Game room? Maybe. Home? Nah.

Carlos Neville, one of the original eight YA/YA Guild members, remembers what made him come to YA/YA. "There was nothing else to do," he says. Real simple. Nothing else to do.

And at first there wasn't much to do at YA/YA, either. There was no organized program, no paid staff to welcome and shepherd teenagers, no particular bond of

trust to count on. There was just this one lady and her building, around the corner from school. She simply offered a place to come to, to do something interesting and maybe make a little money. And they came.

Jana's World

Jana Napoli is standing on the second-floor balcony of her beautiful workplace, a nine-

teenth-century wood-and-stucco town house on Baronne Street in New Orleans. The building houses her painting studio on the second floor, a luxury apartment that she rents out as a bed-and-breakfast on the third floor, some storefront gallery space, and an array of objects she has collected on her travels around the world.

From the balcony Jana can see the bus stop on the corner of Baronne and Girod where Rabouin students congregate after school. She remembers: "I looked out and saw all these good-looking kids, and I wondered how my neighbors could perceive them as a threat."

Much has been written about Jana and her role as YA/YA's founder. The easy angle to take is the one she is least comfortable with: that of Jana as savior, as "great white hope." When she perceives that a

YA/YA-flavored B & B dining area, 628 Baronne Street.
Photo by Carlos Neville, New Orleans

39

Tarrie Alexis and "western" chair, 1993.

Photo by Carlos Neville

journalist is about to write one of these, she invariably says, "Look, honey, if you are going to write that I'm the Blessed Virgin Mary who has gone and saved all these poor worthless nigger kids from life on the street, you can just get out of here."

It is a sensitive issue because it is easy to focus on Jana. The odd truth is that YA/YA is an organization that primarily benefits African American students but was created by a white female artist with extraordinary characteristics. And because she is unique—and eccentric (she reads palms and relies on handwriting analysis when considering potential staff members)—it is easy to become fascinated by her. Also, many talented students come through YA/YA's doors, but there is only one Jana, and she is the heart and soul of YA/YA. And whether or not you believe that there is actually information contained in the palm of your hand or in your handwriting, it is clear to anyone who meets her that Jana is a seer of souls, a zany visionary who is sophisticated and savvy and generous.

Jana created YA/YA because she could see that young people are underutilized in our society, their special talents wasted at a time of peak energy in their lives. She also believes that it is up to adults to give young people the opportunity to develop their talents and contribute something to their communities. Sure, many teenagers have loving, involved parents who encourage them to participate in choir or football or some other outlet for their talent and energy. But

many others do not. And in the case of the Rabouin commercial-art students, the normal extracurricular offerings were not as compelling as the opportunity to come together with friends in an environment brimming with chaotic creativity, to make art, and to make money by *selling it.*

Tarrie Alexis, a third-generation YA/YA Guild member, says, "I could've found other stuff to do, other things that I liked. At first painting wasn't one of them. But once I got into YA/YA and started doing artwork, I was able to appreciate art and see what it was for. I started understanding what art meant to other people. And once I learned how to paint better, I started *really* getting into it. I didn't want to leave."

Christmastime. Several thousand people are gathered in and around Jackson Square in the French Quarter for candlelight caroling. A couple of hundred of them are in Jana's third-floor apartment in the eighteenth-century Upper Pontalba, the oldest apartment building in the nation. Jana's home is a whimsical environment that looks like a cross between a Mexican shrine and an elaborately decorated puppet theater. It is lit with white candles, little votive ones and tall skinny ones, candles in glass lanterns and candles in saucers on every table. Guatemalan garments hang from racks high up on the thirteen-foot rose-colored walls, kites and dolls from around the world are suspended in flight and dangling from the towering Christmas tree that dominates one side of the parlor. A fire

crackles merrily in the marble fireplace, illuminating Jana's richly textured portraits of friends and mythological figures. And there is Jana, introducing the YA/YAs to her friends, making connections that will benefit this one who needs a scholarship to Loyola, or that one who wants to work in film. Her world is large and inclusive.

"I never meant to start an organization."

Fall, 1988. New York City. In a conversation with a woman at the Art Students' League, Jana describes how she has just started working with these high-school students and would really like to help them get into college. "Well, why don't you get *scholarships* for your group? You mean you're not applying for scholarships for them?" Jana is thinking, "I don't even *have* a group yet, how can I get scholarships?" The woman tells her about nonprofit status for her "organization." Jana thinks, "What organization?"

Jana comes home from New York and incorporates YA/YA, Inc. in November 1988. She tells the students, "I remember what it was like when I sold my first painting. It was like the coolest thing that ever happened to me—it was like, *wow!* I thought maybe I could be smart enough to do that for you."

After the first show, Jana invites some of the students to keep coming to her studio after school. She suggests that they paint their stories on furniture. "I wanted some-

thing that they couldn't fail with," she explains. "It's hard to sell a painting on a canvas." What she envisioned as a small exhibition in the front hallway quickly becomes a full-scale training operation that occupies about a third of her building.

The Art of Teaching

Jana sits on the floor and explains with her hands why the boy's design would be better if only...*here:* she scrapes with a razor blade thickly applied paint. The boy fidgets. You have this shape here, but then it's gone, it's not repeated anywhere except maybe in this red spot. See? No. She takes his hand, leads it, no, *here, see?* She pulls, literally tugs the stories out of them. She knows that she is tugging at something deeper and that if she can just get them to

Jana Napoli and Rondell Crier, 1990.

Photo by J. Dexter Stewart, New York; inset, Michael P. Smith, New Orleans

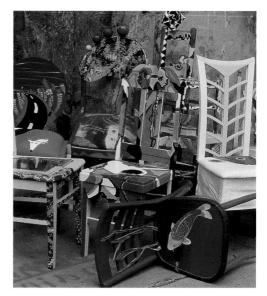

YA/YA chairs on Toulouse Street in the French Quarter, 1992.

Photo by Michael P. Smith, New Orleans

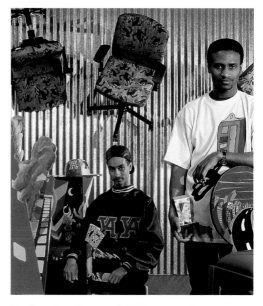

Carlos Neville and J. Dexter Stewart at YA/YA exhibition in Architects and Designers Building, 1992.

Photo by Eliott Kaufman, New York

stretch, maybe something wonderful will come out. Usually she succeeds.

Others help. Madeleine Neske, excited by Jana's willingness to help her students, volunteers her time after school and on weekends. She recruits students and serves as YA/YA's liaison with the school. From the beginning, Jana wanted no formal link with the school system. She perceived it as dysfunctional and cumbersome. To this day, YA/YA's only connection with the Orleans Parish school system is a commitment to work with students and graduates of Rabouin because YA/YA and the school are neighbors.

Give In and Get Organized

Winter, 1989. Jana takes a trip to Mexico. Carlos says, "Miss Napoli was taking her trip saying, 'Whew, that sure was nice hanging out with those kids. Boy, that was very fun. Glad that's over.' Came back and everyone was hanging out in her house and all in the gallery—'What are they still doing here?'"

Jana, "trapped by fate," as she says, accepts the fact that she is probably going to be sharing her studio space with the YA/YAs for a while. Carlos remembers, "We had been over there almost every day for nine months! We kept bringing in furniture from off the street." In addition to the contribution of her time and her building, Jana continues to plow her personal resources into the new program. So far every dollar spent on YA/YA has come out of Jana's pocket.

That includes a modest salary for a tall, lanky thinker with a wry sense of humor who helps Jana sort through the federal forms, open a checking account for the organization other than her own, and match wits with the YA/YAs. Walter Brock, whose experience includes having founded a community radio station, serves as YA/YA's administrator for its first three years and some months. Even more important, he serves as YA/YA's masculine buffer, helping Jana to understand the boys and vice versa. Walter develops a jocular, big-brotherly relationship with the eight Guild members and with most of the later YA/YAs, keeping track of their sales, making sure they get paid what is owed them, lending them money out of his own pocket, joking with them, staying with them till all hours to finish their artwork, bringing them down to earth and, often, all the way home.

Staff increases with the addition of myself as director in late 1990. YA/YA, it seems, is here to stay, and Jana is desperate for someone who can raise money and "help with the kids."

A Saturday morning in September 1990. I am sitting in my house thinking about this woman who works with young people and gets them to paint chairs. As assistant director of the local arts council, I manage the grants program, but I don't know much about YA/YA because it has never applied for funds from us. Still, my boss has asked me to contact Jana and see

what I can do to help her. I look around at my extensive collection of children's chairs, scattered throughout my house, hanging on walls and sitting on tables, and I smile at what might be called a coincidence. I call her up, offer to help her write a fund-raising proposal, and tell her that maybe she should hire me for YA/YA. "Can you be here in an hour?" she asks.

I go down to Baronne Street and, led by a voice on the intercom, wander up the four flights of stairs to the apartment on top of Jana's building. Résumé in hand, I am curious and a little nervous. There is Jana, standing at the sink, washing a large pot. We talk for a minute or two, and I sit down at a long cypress table to take notes. She falls into a chair across from me, puts my résumé, still in the envelope, off to one side, and takes both of my hands in hers. Palms up. She begins to describe me, showing me this line that says I'm smart, or this one that says "good administrator." Then there's this one, she says, that tells about my childhood, about disorder and the resulting need to control. I am astonished. I ask her if there is anything else she needs in order to know if I am the right person for the job. "Well, I'd like to take that page of notes you're writing and fax it to my friend Felix the graphologist. He'll tell me anything else I need to know." Apparently I pass, because a short while later I become YA/YA's first director.

Together, Jana, Walter, Madeleine, and I begin to construct something that resem-

bles an "organization." We start having regular weekly meetings with the YA/YAs and with one another, writing down the few rules YA/YA has, such as that members must be enrolled in school and maintaining a C average in order to participate in YA/YA. We also begin describing the organization and the YA/YAs' accomplishments in words that people who give money away can understand. YA/YA is on its way—into the hearts and minds of people who care about young people, and into the coffers of those who can afford to educate them.

Listen, Lionel Milton, 1992.
Photo by Michael P. Smith, New Orleans

chapter 2

TRUST AND FEAR

OST people who buy YA/YA artwork believe that they are making an investment in someone's future. So the real product is not the artwork, it is the young person who is creating it with his or her stories and images and sweat. But in order for most people to be able to see that, the artwork must be authentic, honest, and real. These are the qualities that come through the work. The artwork is a vehicle for individuals to reveal what is inside them. It is up to adults to help youngsters discern what is real about themselves, to help them separate it from what is simply trendy, and to help them be comfortable about revealing it. This is a tall order. This requires trust. Trust of self and trust of others—whether it be Jana's art direction or the bookkeeper's accounting—trust is the key issue, the one that underlies all the YA/YA stories and experiences, that shapes our perceptions of what we see and dictates what we do, at YA/YA and out in the world.

Trust is the critical core issue that shapes both our successes and our failures at YA/YA. This is no surprise: it is the same in society. People with differences have a hard time trusting each other. But we are all different. So how come we trust some people but not others?

Fall, 1988. Jana is standing outside YA/YA in her bare feet hosing down the front windows. One of her neighbors, a business owner, passes by and starts talking to her about the YA/YAs. "How can you let those kids into your building?" he asks. "They might steal something!"

Fall, 1988. A young YA/YA member is talking to her grandmother about this lady who has asked a bunch of the Rabouin students to come and paint furniture in her studio. She has even promised them a show, and they can keep some of the money if stuff sells. Her grandmother warns, "Don't you go into that white lady's building. Something turns up missing and she's going to say you stole it."

There are some very basic assumptions in both stories. The biggest and most glaring one is that white people can't trust blacks and black people can't trust whites. Once we are divided by race, then we further separate ourselves by gender, by age, by whatever. Since most of the first YA/YA students were black male teenagers and the organization was founded by an adult

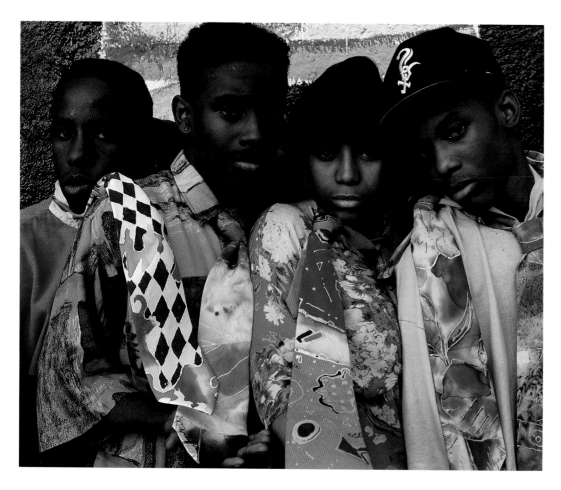

Jerone Thornton, Edwin Riley, Shazell Johnson, Rondell Crier, and hand-painted ties, 1992.
Photo by Michael P. Smith, New Orleans

Sketch, Miguel Griffin, 1995.

white female, the potential for mistrust was considerable. Even greater, however, is the potential for the *perception* of mistrust: In a racially diverse organization, when two people have a disagreement, it is very easy to blame it on race, when in fact the root of the argument may be something else entirely.

Spring, 1994. A muggy Tuesday afternoon. Jana's assistant, Ann, a young white woman who helps manage YA/YA during Jana's frequent absences, is talking with Rondell, a senior YA/YA Guild member and intern, about the proper procedure for

checking out slides. Rondell has taken YA/YA's original slides of his work, shot by a professional photographer, to send somewhere, instead of making duplicates of them. Ann is telling him why this is unwise. He doesn't see the problem. There were several shots of the same piece, so what if he sent out a couple of them? In an effort to get him to acknowledge the value of YA/YA's documenting his work through slides, Ann points out that YA/YA does a great deal for him. "Where else could you earn five dollars an hour while learning a skill? Most internships don't pay anything!" He counters, "If you get to know how much money I make, why can't I know how much you make?"

She is hurt and confused. She feels he is hindering her ability to do her job. She thinks he doesn't know very much about the real world or how lucky he is to have the support of YA/YA while he is in college. She doesn't understand why he questioned her salary or why he got so angry.

He is furious. He thinks she is putting him down. He resents the fact that she is only three years older than him but has already finished college, is considered a "professional," and is in a position of authority over him even though he has been part of YA/YA longer than she. He doesn't know anything about the system for checking out slides. Just another stupid rule they made, he thinks. They're slides of my work, so what if I take them?

The issue is not the slides. The issue is

trust. The absence of trust is why the discussion departs from the slides and leaps blithely over to the issue of appreciation of the organization's role and then even farther, into the issue of pay. We have learned that whenever something that illogical happens between two people at YA/YA, the real problem is something besides what they seem to be discussing. Usually it comes down to how much the two people trust each other—to be fair, to have the other person's best interest at heart, to be consistent. And nowhere is the question of trust more laid bare, more out in the open, more apt to walk up and slap you in the face, than in an art studio, where people take the great risk every day of creating something with their hearts and souls, then wait to see how others react to it. Taking

risks makes us afraid, and fear exacerbates misunderstanding.

Coming from a Different Place

Most of the misconceptions we have, at YA/YA and in American society, are cultural in nature. They are caused by a lack of information. Jana says, "It's not so different than not knowing what Dutch people think, or what Mexican people think. It's a different culture and a different world."

She's right. The United States is not a homogeneous environment. It is the largest cultural melting pot on the planet, and yet most of us are not close friends with our neighbors of different colors or with those who have considerably more or less money than ourselves.

New Orleans is a particularly confusing

All images: YA/YA mural at St. John the Baptist Community Center, New Orleans.

Photos by Michael P. Smith, New Orleans

environment precisely because its population is so multicultural. When you travel to Japan or Italy, places with few immigrant residents, you can expect to see people with a particular skin tone, to taste food seasoned with particular spices, to hear a particular language on the street. Not so in the urban areas of this nation and especially in New Orleans, whose culture incorporates Afro-Euro-Caribbean influences, immigrants' descendants, and racially mixed inhabitants. In this strangely dreamy city the lines of race and social order are not clearly drawn. Some of the finest houses in the city's magnificent Garden District are mere blocks from some of the poorest housing developments in the nation. And during Mardi Gras season the residents of those fine houses stand side by side with their poorer neighbors competing for the same trinkets thrown by people riding on floats in the parades. So although there is some opportunity for contact between people of dif-

Top to bottom: *Music to the Bone,* Brandon Duhon, 1996; *Jazz Man,* Caprica Joseph, 1994; *Gimmie Some Gumbo, Baby,* Caprica Joseph, 1994.

Photos by Michael P. Smith, New Orleans

ferent races and income levels, the experience is often in the realm of the extraordinary—like Mardi Gras—and therefore does not provide us with any real information about the "other" culture and its values.

Couple this cultural distancing with our impoverished public education system, which sharply divides children by race and family income (most people who can afford it send their children to private school), and it becomes easy to make erroneous assumptions about people who look different, act different and do seemingly incomprehensible things—such as nervously clutching their purses when walking down the street or carrying sound systems blaring on their shoulders. We see these things and we don't understand, and our confusion makes us angry.

A morning in late fall, 1992. Jana and I are meeting with some representatives from a national philanthropic foundation that supports programs benefiting "urban youth." We are trying to convince them to give YA/YA money—$50,000—to support YA/YA's new fabric-printing workshop. Private foundations are organizations whose purpose is to support worthy causes, most of which, like YA/YA, have been designated "501(c)(3)" charities by the Internal Revenue Service. Foundations always get more requests for money than they can possibly fill, so our job is to convince these people that YA/YA is a worthier recipient than some other group. Often representa-

tives from foundations visit the organizations that are applying for funds, to check them out, meet the people who are running the program, and see the site. Three representatives have come: the director, a fatherly type who has been in the business a long time; a young female program officer; and an even younger man who is assisting them. They seem open and friendly.

It is quiet because the only time the foundation folks could schedule their visit was in the morning and the YA/YAs don't arrive until after school. After we give them a tour of YA/YA, we bring them back to sit at our long wooden conference table (salvaged from an old school building) in the office. The discussion turns to issues of trust and race. We are trying to explain to them why there is absolutely no reason for black teenagers to trust white adults. "What have we ever done for them?" one of us asks.

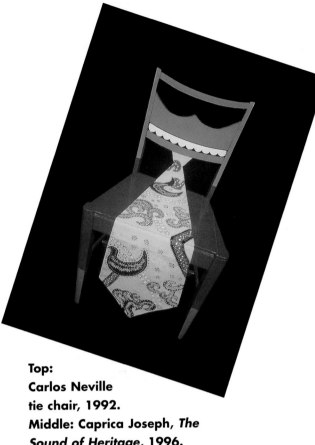

The look on the foundation director's face tells me that he sees the problem from a very different perspective. "Oh, I don't know about that," he says, and he cocks his head to one side in pure doubt, waiting to see what we will say next. Uh-oh! We have made a blunder of some sort. In our heads we step back and consider our options. Do we try to explain further and risk getting ourselves in deeper? No! We change the subject, begin talking about YA/YA's particular program and how it helps young people learn job skills and spend their time productively.

It is clear that although we all care about young people, we view the problem of trust between the races *very* differently. Maybe the director believes that he and his colleagues have done a great deal for black youngsters—indeed, he spends most of his week visiting programs like ours and making funding recommendations.

We, on the other hand, see the great gulf of misunderstanding that still remains, despite the funding, despite YA/YA, and despite our best intentions.

An Even Wider Gulf

April 1991. Jana and I are having lunch with a respected member of the New Orleans business community, an older white man in a pale blue seersucker suit who has won numerous awards for his involvement in various good causes. We are hoping he will help fund our upcoming trip to Europe for twelve YA/YAs who have worked hard to have the requisite B average in school as well as good participation in the program. He looks up from his crab soup and says, "But why take these kids to Europe?"

Top:
Carlos Neville tie chair, 1992.
Middle: Caprica Joseph, *The Sound of Heritage*, 1996.
Bottom: Carlos Neville crucifixion chair, 1990.

Photos by Michael P. Smith, New Orleans

The response, of course, in our minds is, "Why send *yours?*" But in order to save the gentleman's face, and so as not to embarrass Jana's friend Leonard, who introduced us to this pillar of the community, we say, "Oh, but it's great for young people to see other cultures, especially these youngsters who have had very little opportunity to go outside of New Orleans." We add, "It's also great publicity for the city to have young African American designers serve as cultural ambassadors abroad. The YA/YAs have actually been asked by the French government to work with their own youth—French youngsters of North African parents—and help them paint murals in their housing projects."

We hope, while we are sitting there, that the gentleman can see the value of this. "I see," he replies, moving on to his shrimp remoulade. But we can see that he doesn't really see, and neither of us feels much like eating dessert.

"If you treat those kids like niggers long enough..."

Jana never felt she had much in common with her neighbors. "Everybody was walking around in my neighborhood looking like, `Get these niggers off of my street.' I'd just go up to them and I'd say, `Listen, if you treat those kids like niggers long enough, you're going to make niggers out of them, and they don't deserve that. They're really nice kids.' That's what they were thinking, but they'd never say it. They

wore white shirts and silk ties. It wasn't cool, they never used *that word* because they were too educated. They just thought it. So I used to just say it, throw it in their face."

It didn't make her many friends, at first. Later on, once the YA/YAs had begun to appear in magazines, people—especially those in the central business district who were accustomed to seeing the YA/YAs come in and out of the gallery—began to feel a sense of ownership of YA/YA. Jana says, "Now, instead of fearing them, local business owners say, `Hi, are you a YA/YA?'"

Beating the System

Reactions from the community at large to YA/YA's success range from encouragement to disdain. YA/YA takes young people who do not have access to the opportunities and information that other, richer, and yes, usually whiter youth have that increase their chances for success, and gives those things to them. Jana explains to the YA/YAs that their lack of information about what the market will bear, what kinds of work are selling in different places in the world, has put them at a disadvantage: "That's what happens with the educational system. That's how you get systematically excluded because of your color. They say, `Oh yeah, he's black so we know what kind of education he got. I bet he can't do this, that, and the other,' because they know you didn't have access to information

you needed to grow to your skill level. So what I did was I hot-wired it. I tried to do it with the least amount of damage I could, to get you all into the system and out there seeing where everything was so that all of a sudden you were getting the education of the children of multimillionaires. Because that's how they're so smart. They speak three languages, they've been to Paris, and they notice what the market is like and how people talk to each other. You have the same skills, but you didn't have the *access*, and I was trying to jump the wire, going up to New York, over everybody's head. I'm going to tell you, the art community didn't like it one bit. They liked it in the beginning, they thought it was wonderful, but in the middle, when they saw the kind of success we were having, they didn't like it. They said, `Who do these kids think they are? They think they're artists?' I said, `Oh no, just because they're in museums doesn't mean they're artists, does it?'"

On the other hand, some people could not be more supportive. Often they are those who are genuinely interested in the YA/YAs as individuals. They see that the YA/YAs, not the artwork, are YA/YA's real product. These are the folks who see the artwork as a *vehicle* to the individual. Walter Brock describes them: "Everyone doesn't have a high training in art. They can see how this color works, and it communicates something to them, but they usually need to have something to grab onto, like why does the artist have this vision or

where did this visual come from? People respond to feeling like they can come and find out something about what inner-city kids are thinking, and art is a safe place for them to do that." Jana laughs, "They weren't going down to the 'hood." Walter replies, "Yeah, people are afraid of the 'hood, but they are also curious about the 'hood. So after YA/YA, then there's all these movies about the 'hood, and it's not just kids going to see them. It's all these other people going to see them that are curious."

Using the Fear

It takes a while to turn fear into curiosity, but Walter remembers how he and Jana used people's fear and confusion about black youth to get them in the door and ultimately sell them the YA/YAs' artwork: "Being black and being mean is kind of exotic. You take this thing that they [white people] are kind of afraid of, and you put it into a safety zone, and they can come in and look at it. We adjusted the stories, the way we talked to these people, a little bit because we knew it would get them excited and they'd come in."

Jana agrees. She explains to the YA/YAs: "Right, they were still going to grab their purse because they were scared and they were old, but I thought that if they had a dialogue with you, bought your picture and took it home, then you're in their *house*, you're part of their environment. Their curiosity about you has a little bit

longer life to it. So that all of a sudden you're a person, you're not just the threatening black hoodlum on the street in tennis shoes."

The Other Side of Success

Of course it is not just older people or white people who experience fear. Sometimes being young and successful can be scary, too. In fact, sometimes it is downright paralyzing. Carlos remembers how he felt after his first piece of furniture sold: "If you do something and it's for the very first time you ever did something and everyone in the world is telling you that you are a genius...I didn't know how to handle it. So every piece that followed after that...it was so hard because it had to be just as good as that. It had to be just like that. I wanted to make people go amazed and call me a genius again!"

Jana remembers, too. "You couldn't get anything out of him for a year." Carlos froze. It is very hard to live up to what you perceive other people's expectations of you to be. And if you do something great the very first time, it is easy to think that maybe it was an accident. You are standing there and someone is admiring your work and telling you that you are gifted, and you are thinking, "Boy, if you only really knew me, you wouldn't say that." This is a common problem for creative people, especially young ones. It is particularly common among people who do not have a clear picture of themselves.

"You want to do what? You want us to cash your check so you can go buy shoes on Canal Street with it? Forget it, you're not getting your check until you write this thank-you note to that woman who bought your chair." From the beginning, Jana has insisted that the YA/YAs learn how to work with clients and thank them for their patronage. Sometimes the YA/YAs think this is autocratic. Jana thinks it is a vital part of their training to be young entrepreneurs because, besides good press, the next-best job generator is clients' word of mouth.

Ready or Not

Getting people to move through their resistance to success is a tall order. Often at YA/YA we see someone being offered a great opportunity and yet finding a way to shoot himself in the foot so that he can't take advantage of it. Like the time the YA/YAs were given the chance to design watches for Swatch. Five or six YA/YAs submitted preliminary designs, and Swatch asked for some modifications. One YA/YA complained that he was tired of making changes: "This is going on too long." My response was, "Man, a professional artist would give his eye teeth to get an opportunity like this. What do you *mean* you're too tired?" "I ain't no starving artist," he said. "I'm not depending on this to pay the rent."

Maybe part of this outlook is laziness, part teenaged lack of focus. But part of it is fear of success and fear of failure, too.

For most of us it goes something like

Red Beans and Rice stool by Gentelle Pedesclaux, 1996.

Photo by Michael P. Smith, New Orleans

this: If I try my best and I don't succeed, then I have failed. But if I don't try too hard and I don't succeed, then I know that I haven't *really* failed because I could have done better *if I had wanted to*. At YA/YA we have found that the remedy for this syndrome is to keep pushing the YA/YAs to produce, and to let them taste success in bites that are small enough to swallow and digest. One means of doing this is to encourage collaboration on large projects so that everyone shares in the success and yet no one person's work makes or breaks the job.

For example, when YA/YA was asked to paint the Majic Bus, a group of YA/YAs worked for days submitting individual images that the older YA/YAs managed to shape into a collage. When the design was transferred to the bus, whoever made the image oversaw the painting of that piece of the whole. The result is a unified artwork that consists of many different components, each of which was carefully crafted by the person who cared the most about it. The result is a piece that sings.

Working together like this produces a common culture that can be referenced and that means something to the participants. In the YA/YA family, everyone knows what it means when someone talks about "Darlene's blue" because it is the particular shade of midnight bluish-purple that Darlene has used on so many of her pieces. Jana says, "Everybody's got different things, like Chris's joker, Courtney's roses.

We begin to have a language." And having a language means that communication becomes much more effective. When you can speak in shorthand, you don't have to say nearly as much to get your point across, and after a while you begin to see similar pictures in your collective mind's eye. It makes collaboration much easier and much more integrated. Successful collaboration is like the difference between just clasping your hands and lacing your fingers together. It creates a tighter fit, a weaving of ideas and images to make a unified whole.

YA/YA's Hope

Although we do not presume that YA/YA will cure America of its communication problems between people of different income levels, age, race, gender, or outlook, we do believe that the YA/YAs' success has created a conversation about creativity and its origins that did not exist before. There are at least several thousand people in the world who have heard or read about us, or seen YA/YA work, who look with new eyes at what it is possible for young people to produce. And maybe some of those people will look not only at the YA/YAs' artwork but at the YA/YAs themselves. And if *this* happens and people are inspired to offer access and opportunities to youth in their *own* neighborhoods, and *those* young people get written up in the newspaper, and more people read about *them,* then maybe, just *maybe,* YA/YA will have had some

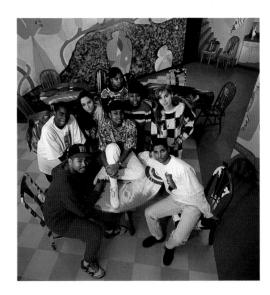

YA/YAs at Blumenthal Print Works headquarters, New Orleans, 1993
Photo by Michael P. Smith, New Orleans

Majic Bus, 1994.

small part in erasing racism in this one small corner of the planet. We hope so.

In the meantime we focus on using YA/YA's success to establish trust among ourselves, to strengthen the unit we are becoming so that we may do more. Jana tells the YA/YAs, "I realized in the beginning that there was no reason for y'all to trust me, and it was okay. I fell out of the sky. Who the hell was I? In the beginning it was like you were watching me to see what I was gonna do...like you watch a new dog who walks on the street, or somebody who moves into a house next door."

Trust does not come overnight. It is a destination that requires long travel together to reach. We know we are not there yet. But we are much closer to it now than we were even just a year ago. The one thing that we do know is that real trust requires a "letting go" on everyone's part—of expectations, of prejudices, and of the illusion of control. Once we do that and allow others to take some portion of responsibility or credit, we find ourselves curiously relieved. Only then can we share our triumphs and our failures with one another—and the ability to do that is the definition of true success.

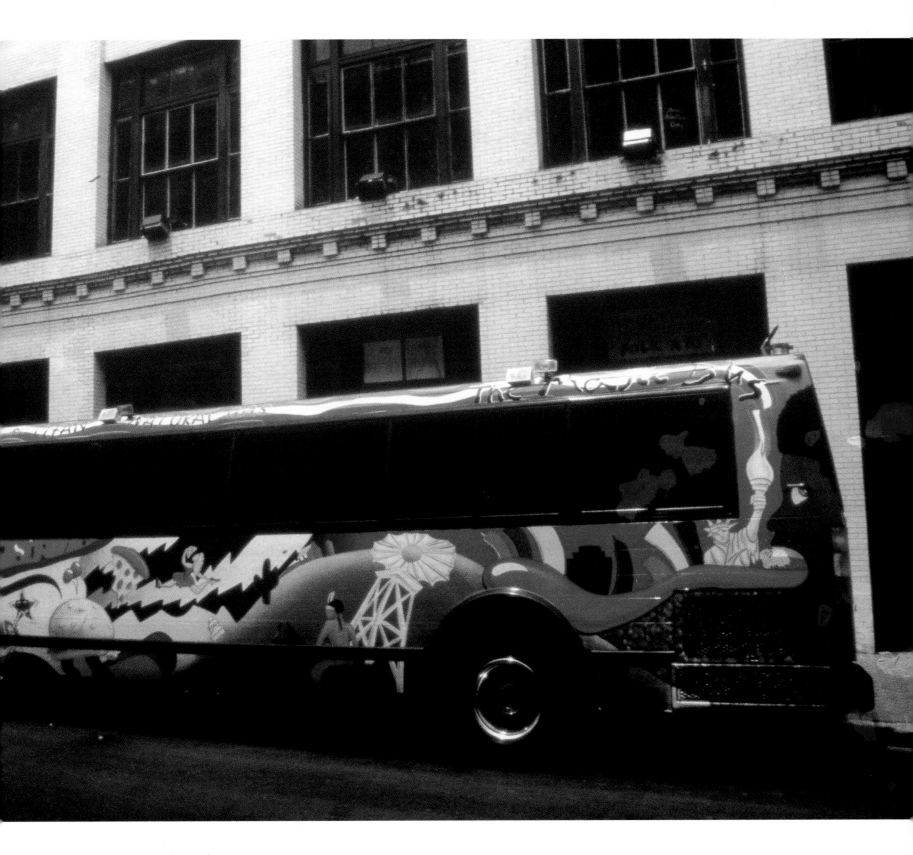

Drawings from YA/YA's inaugural exhibition, 1988. The artists were (top) Leroy Scott, (middle) Sharika Mahdi, and (bottom) Darlene Francis.

Photos by J. Dexter Stewart, New York

chapter 3

SPREADING THE
RIGHT WORDS

UCCESS comes to YA/YA because people become aware of the program and buy into its mission. They read about the organization in the newspaper or see a colorful photo of a YA/YA chair in a magazine and stop to read the story. YA/YA's initial success is due in large part to press coverage of its first exhibition, in November 1988, featuring students' pictures of buildings in downtown New Orleans. Roger Green, the *Times-Picayune*'s art critic, reviews it, generating excitement, sales, and eventually more press. Green names some of the landmark buildings that the YA/YAs rendered in media ranging from pen-and-ink to crayon and says, "Yet if the buildings are recognizable, they have a disarming new look. Expressive distortions mark the students' objectively crude but subjectively on-target drawings, which often are crowded with keenly observed detail.

Never has the CBD looked more endearing, or worn such an open face." He adds that the drawings "manifest the freshness and directness of vision that has fascinated so many 20th-century artists, beginning with Paul Klee."

Both the initial exhibition of painted furniture, held in New Orleans in March 1989, and a slightly scaled-down version that travels to Lincoln Center the following month also generate much excitement. The show gets written up in the *Times-Picayune*, in *New York Magazine,* and in *Metropolis*—major coups for a group of young student artists.

Walter Brock credits Roger Green with drawing attention to YA/YA and starting the presses rolling in YA/YA's direction: "Roger was very, very kind in that first review. He took it seriously and respected what was going on. What was going on seemed to be real honest and fresh...and that's what got all the first rounds of publicity."

Thus begins YA/YA's love affair with the media. Whether it is because of the uniqueness of sophisticated artwork being done by young people, the quality of the designs, or the magic that happens when Jana Napoli works with youth, it seems that everyone who writes wants to write about YA/YA. Another plus is that the YA/YAs and their work are extremely photogenic. There is nothing quite like a shot of an exuberant sixteen-year-old jumping up in the air while holding onto a piece of

Drawing by Fredrick Dennis, YA/YA inaugural exhibition, 1988.

Photos by J. Dexter Stewart, New York

furniture that tells his own story, painted with his own hands.

Whatever the angle, whether it is interior design, education, or human interest, YA/YA has been featured in more than eighty publications. Included are major

"Three years ago, a New Orleans artist and gallery owner named Jana Napoli corralled a group of teenagers from a nearby high school for free art classes. Ms. Napoli, 45 years old, urged them to paint their dreams, hopes and fears on junky, castoff furniture. The result? Furniture not necessarily comfortable or even chic, but so alive it seems to kick, shout, do handstands and weep."

—Mimi Read, "Style Makers: Young Aspirations/Young Artists, Furniture Designers," New York *Times,* February 2, 1992

"A brass band played as the YA/YAs boarded a flight for New York in spring 1989 for a show of their work at Lincoln Center's Cork Gallery. All 32 pieces sold out. Carlos Neville's extraordinary chifforobe with harlequins on the outside, needles and knives on the inside, was the first to go."

—Peter Hellman, "Sold Out! YA/YAs Market Their Hopes and Fears," *American Visions,* February 1991

Carlos Neville and his clown baby chifforobe, 1992.

Photo by Michael P. Smith, New Orleans

magazines like *Life, Vogue, Metropolitan Home,* and *Fortune,* big newspapers like the New York *Times,* and not-so-big ones like the Baton Rouge *Advocate.* The YA/YA story has also spread abroad through vehicles such as the Italian magazine *Abitare,* the Dutch magazine *AvantGarde,* and Japanese publications like *Pop-Eye* and others.

Early on, Jana saw the value of publicity for YA/YA and pursued it like a hungry tigress. Why? Because for many people, including many of the students, their parents, and potential collectors of their work, read-

ing about something in the newspaper or seeing it on TV makes it real.

August 27, 1989. Jana and Carlos are frantically turning pages of the *Times-Picayune.* Someone has just called and told them that YA/YA is featured in the Living Section. Here it is—a story by the art critic, with pictures of the students and their work. "Wow, Miss Naps, how many people read the newspaper?" Carlos asks. He thinks about it for a minute, then says, "How can we keep on getting in the newspaper? This is *cool!*" At that moment and for a long time afterward, he is a star. And when the memory of that feeling begins to fade, he wants to feel it again. Photo shoot on Thursday? No problem. Because seeing yourself and your work printed in a magazine feels *sooooo good.*

Because the media is hungry for good news stories and because YA/YA had the story, the work, and sometimes even the professional-quality photographs to feed it, one could say that in the beginning YA/YA received a disproportionate amount of press coverage in view of its modest output. But that forced the organization to grow up fast. "We grew into our press," Jana says. "We got all that stuff and it happened real fast, and now it seems like we're growing into it. Because in the press we don't sound like a bunch of fools running around screaming and yelling at each other—do we? We sound like we're on the nickel, like we're ready to roll! Some people do it the other way around."

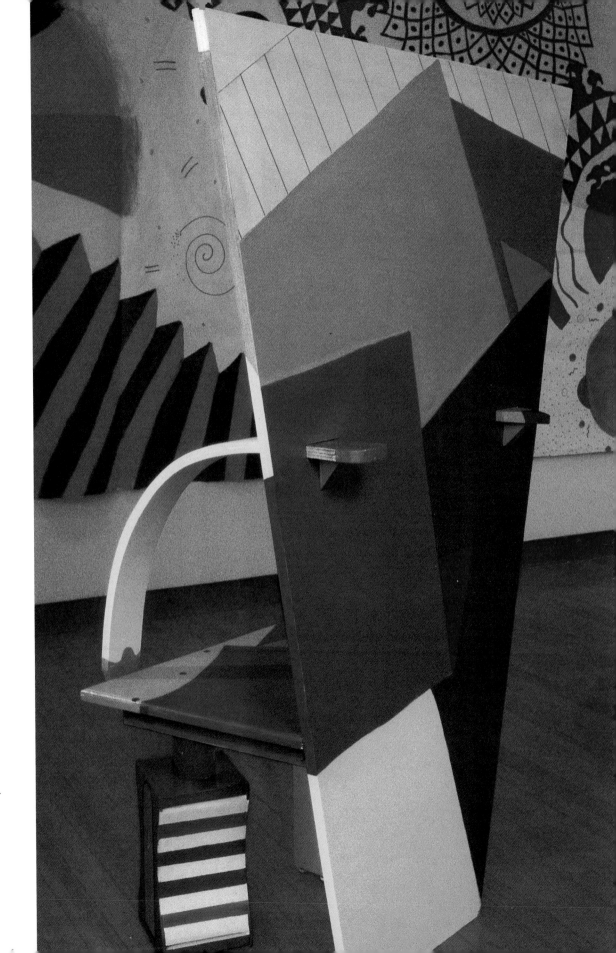

Rondell Crier's *Line Creator* chair, collection of Alessandro Mendini, Milan, Italy, 1994.

Photo by Michael P. Smith, New Orleans

"Luck is something you make."

Jana made sure that the YA/YAs' work was honest and well crafted. She also made sure that YA/YA, even when it was newly formed, was able to turn on a dime. Walter Brock remembers the program in its infancy: "It wasn't organized, but it was responding to opportunities." Jana says, "Anything that came by, we said let's take it, let's go for it. They'd say you gotta do it tomorrow. We'd stay up all night. I never said no."

Rondell Crier calls this luck. "You can't define it," he says. "It just popped up." Walter Brock sees it differently: "Luck is something you make. You gotta be active enough so that you're already in motion whenever the opportunity comes." YA/YA was in motion because Jana saw an opening in the market and recognized that the talent needed to fill it was right there in the form of the Rabouin students. She says, "I saw millions of people painting on chairs in magazines, and their stuff looked so bad I thought that none of us could do anything as ugly as they're doing—let's go for it! We got a shot at this market."

The Market

Besides her skills as a painter and art director, Jana offers the YA/YAs market savvy.

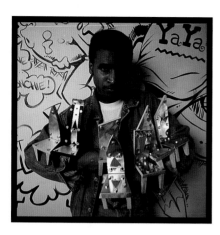

J. Dexter Stewart and his minichairs, 1991.

Photos by J. Dexter Stewart, New York

"You go downtown and they got ten pairs of trousers you like. You have money for one. Which one do you buy? What makes you fork out money for one thing and not the other thing?"

This is a key question. Jana tries to answer it for the YA/YAs every day. She does it through observation ("None of the stuff with gold on it sold") and by being very aware of what's going on in the world (she travels extensively, to New York and other American cities, to Europe and Asia, always scouting for YA/YA).

A constant stream of pictures, interior design magazines, and books informs the YA/YAs about what's hot. Nothing with pic-tures in it goes unskimmed at YA/YA. YA/YAs rip pages out of magazines and tape them to the walls of their studio, sur-rounding themselves with images they like: models in beautiful clothes, an elegant chair design, expensive hand-painted rugs. YA/YA operates on the belief that if the YA/YAs know what's going on in the world, their work will reflect it, and that will make it sell. But sometimes there are skir-mishes along the border between what is good and what will sell.

Late fall, 1990. Edwin Riley is arguing with Jana about whether he can paint a Batman chair. The movie is hot right now, Prince made a video about Batman, and it

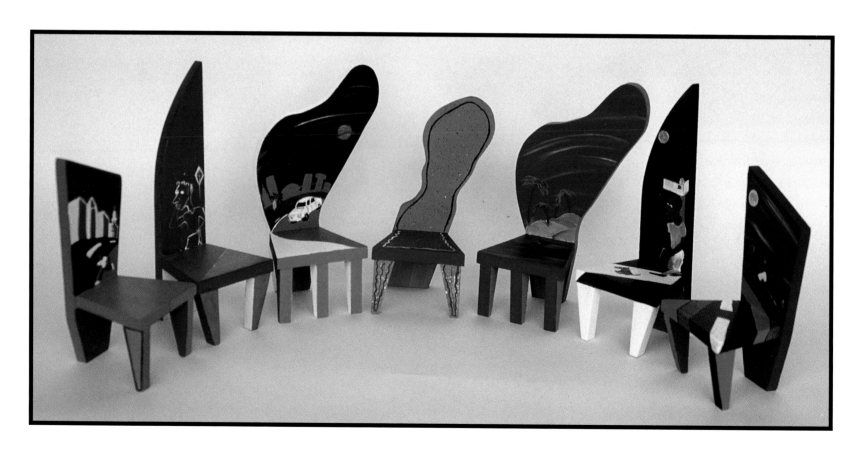

seems as if everything with Batman on it is selling like hotcakes. Jana is adamantly against it. Too commercial. It won't look like YA/YA. Maybe it's decoration, but it's not art. Edwin paints it anyway. He remembers: "My first chair was the Batman chair. It was Batman and the Joker on it. I finished it, and at the show that day everybody else's stuff was selling and I just felt left out because mine didn't sell."

Carlos Neville says, "Everybody has a different kind of visual education, of what they see and what they want to see. You're selling to a wide variety of people, so you have to get opinions from a wide variety of people."

Jana adds, "There's all kinds of people coming in: people who have education about art, education about literature, people who know how to make money. And some people just want to match the green in their carpet. Like when I didn't want to put Shazell's decorative piece on the floor of an art show. Didn't mean the piece was bad. It didn't fit the situation we were going into. We were trying to take this piece to the level of the New York art gallery scene, instead of the shop scene. You don't sell tomatoes in a beauty parlor!"

Quality = Integrity

A balmy Saturday night in September, 1991. Eric Russell is grinning broadly because he just sold a coatrack that he painted for YA/YA's Art for Arts' Sake show, the biggest exhibition of the year. It

is a wooden rack with brass hooks on the top and he has painted it with an abstract design and hung it from the ceiling in the YA/YA gallery. Hundreds of people are wandering through YA/YA and all the other galleries on this night, the season opener. A little while before the opening, Jana sees the piece. She doesn't like it, and she tells Guild member Rondell Crier and Lyndon Barrois, a professional artist and film maker who served as YA/YA's production coordinator for a year, to get Eric to paint some more on it. "It's ugly," she says. But before they have a chance to tell him, someone walks in and buys it! Eric beams. Jana just shakes her head. Because it's not about good or bad, salable or unsalable. It's about the YA/YA style of work, a "look," a level of quality and spirit that the public has come to expect from YA/YA.

Jana strongly believes that quality equals integrity. Her philosophy: "Just because something sells doesn't mean that it's art. Anybody ever go out there and look at what sells? I'm interested in giving our customers the best level of work that fits their needs." Sometimes that means scraping the paint off your piece and starting over. But always, once the effort is made, what comes out of it means "YA/YA."

Press as Motivator

There is an entire wall of newspaper and magazine articles about YA/YA framed and hung in the office. It reminds us that the world is watching us and it keeps us on

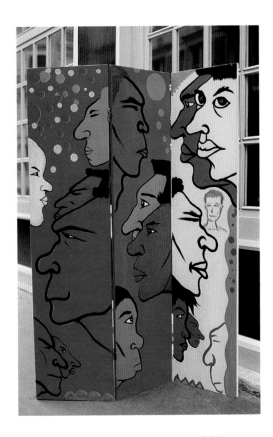

Screen by J. Dexter Stewart, 1991.

Photo by Kymberli Johnson, Chicago

our toes *today* because the world might not be interested tomorrow. We look at the articles and we think we had better keep pumping or, like in *Cinderella,* everything will turn back into mice and pumpkins at midnight. So we use the press as a motivator, always mindful that what is written is only one person's perception of us at a given moment in time. Stories about YA/YA are usually slanted (often toward the "white woman saves black kids" angle) and often sensationalized. They do, however, get the YA/YAs jobs and commissions. So we try to remember that "the map is not the territory." Articles about YA/YA are a description, a road map of what we do. It's up to us to know who we are.

At Risk or Potential Achievers? The Word Game

A Monday afternoon, the time when we have regular meetings with all of the YA/YAs. On this day the YA/YAs are all upset because they've just seen a newspaper article by a writer from Atlanta who came and interviewed them. It is a well-written piece, but the headline reads, "YA/YA: Jazzy Furniture Turns Ghetto Kids into Uptown Artists." One YA/YA says, "We're not from the ghetto." Another: "I live in a house in Gretna, not in a housing project." Our eyes turn to the cartoon mural, created by Lionel Milton, on the front wall of the YA/YA gallery. It features a black kid character who is saying, "Just what dah hell iz ah inner city yoot?"

Much worse, in the YA/YAs' view, than the phrase *inner city* is the term *at risk,* a sociological buzzword that many writers have used to describe the young people involved with YA/YA. It is also a term used by many grant makers to describe a particular population for whom their foundations

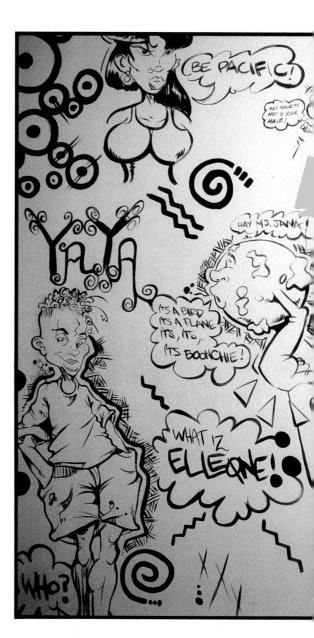

fund programs. Grant guidelines from all over the nation name "at-risk youth" as a priority. So how do you define "at risk"?

"Everyone's at risk," says Rondell Crier, a YA/YA student who comes from a nice home where he lives with his mother and father, brothers and sisters. Rondell is one of three YA/YA students who were jumped in 1992 when walking a little too close to some group's territory near the old Magnolia housing project in New Orleans. I ask him, "Aren't you more `at risk' than, say, your average white guy who wouldn't have even been walking on that street at all?"

Detail of Lionel Milton's mural *What Is a Grit?* 1992, in YA/YA gallery.

Photo by Michael P. Smith, New Orleans

He replies, "You don't know what 'at risk' is if you think we're it."

So what is "at risk"? Are black youngsters more "at risk" than white ones simply by virtue of their skin color? Maybe. Or perhaps the disparity in income levels between whites and people of color has dictated literally which *path* the African American youth are likely to take, and that path is usually more dangerous than the one their white counterparts are likely to take. Maybe black youngsters are simply more "at risk" of being *perceived* to be "at risk" than others and thus seen as somehow "less than" their white counterparts by white society.

Then there is the confusion over whether "at risk" means you are more likely to become a criminal or you are more likely to become the victim of a criminal. Most of the YA/YAs think the term means that they are a *danger to society*—so no wonder they resent being labeled "at risk"!

In any case, the labeling of African American youth who live in urban areas or come from households with a particular income level as "at risk" is ineffective because nobody can agree on what it means. Eric says, "People get the wrong idea. They think we are gangsters and stuff, and we're just a bunch of regular dudes. We're just a bunch of regular teenagers. They just don't know."

Once again, the labels we allow ourselves to put on things limit our view. One person's perception of the "typical black kid" as gangster clashes with another person's view of the same youngster as talented teenager or "potential achiever." These two people could be walking down the same street, in the same city, in the same country, in the same world, looking at a group of young people walking up ahead—and they could not possibly have more different pictures of the same scene.

What to do? Keep walking. Keep talking. Use any *media* necessary to try and establish a means of communication that everyone can understand. Maybe it's English, maybe it's Japanese. At YA/YA, it's certain to be visual. So keep telling your stories with pictures. Keep making art. Keep the faith.

Detail of design by Gerard Caliste, 1995

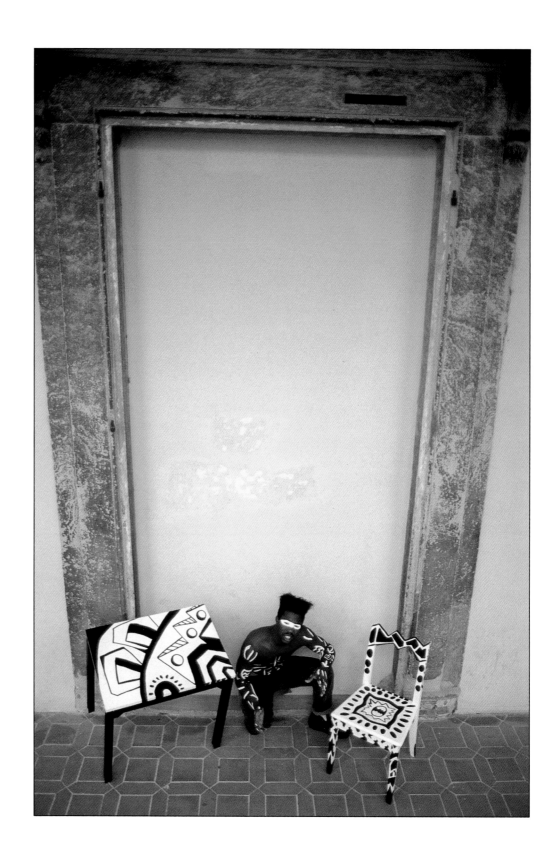

Skip Boyd and his Promosedia chair and table, Sansepolcro, Italy, 1990.

Photo by J. Dexter Stewart, New York

chapter 4
OUT IN THE WORLD

EYOND the market there is the rest of the world. YA/YA sees venturing out into that larger realm as an important part of the education it offers. Also, travel is a vehicle for sharing some of YA/YA's success with others, spreading the mission of self-sufficiency through creativity to people in other cities and countries.

YA/YAs on the Road

From day one, travel has been as big a part of YA/YA's culture as paint and chairs. When YA/YA shows the YA/YAs' artwork to people in other cities we are also usually making personal contacts for the YA/YAs—contacts that often result in a scholarship or an internship opportunity. We go to Chicago to do a job for the Bravo Cable Network, and while we are there we look at a school for Rondell. We find an arts organization that needs a summer intern. It is

a perfect match. He can go live there for a few months, gain some useful experience, check out the city and the school. Bingo. Rondell has his summer all planned. Piece by piece, bit by bit, YA/YA tries to find the right spot for everyone.

YA/YA went to Europe for the first time for the same reasons that its first show went to New York. Jana saw the value of exposing the YA/YAs to a different culture and knew that they and their work would be received very differently in a foreign environment. At home the YA/YAs could be perceived as "those kids" from the local vocational high school. But in Europe, accompanied by articles from *New York Magazine, Life, Vogue Decoration,* and the cover of *Abitare,* they are the art stars from America.

After a brief advance trip in May 1990 to attend the Promosedia (International Chair Manufacturers' Trade Association) International Chair Design Exhibition in Udine, Italy, seven YA/YAs travel with Jana to the little town of Sansepolcro, Italy, to spend the rest of the summer. Tucked into the Tuscan hills, Sansepolcro was the birthplace of Piero della Francesca and a center of Renaissance art. The YA/YAs live in a sixteenth-century farmhouse four kilometers up a steep hill and take art classes at the Accademia de Bella Arti in nearby Perugia. It is a long, hot walk up the hill, and because of some inexplicable complication there is no electricity in the house. At night the YA/YAs paint by candlelight and heat

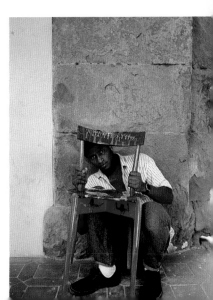

J. Dexter Stewart and his Promosedia chair, Sansepolcro, Italy, 1990.

Photo by J. Dexter Stewart, New York

**Lionel Milton with his signature carica-
ture, Sansepolcro, Italy, 1990.**

Photo by Charles Nes

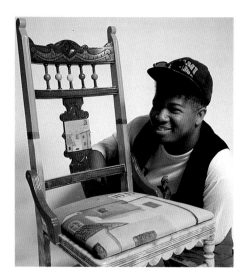

Darryl White with his Piero della Francesca Memorial Exhibition chair, 1990.

Photo by Michael P. Smith, New Orleans

water on the gas stove for baths. Jana re-
members, "Once they were home in the
evening, I knew they were home to stay."
Never mind the crime-ridden streets of New
Orleans. None of the YA/YA city folks likes
the idea of walking miles up the hill in the
dark and confronting snakes or other fright-
ening creatures of the night.

That first trip is an exercise in forced
communal living. With only three bedrooms
and two bathrooms, the YA/YAs, Jana, and
Mimi Landry, a teacher who helps chaper-
one and instruct the group, share every as-
pect of daily living. Despite—or maybe be-
cause of—the somewhat primitive
accommodations (which were free, cour-
tesy of the Italian government), the YA/YAs
are inspired to produce some remarkable
artwork.

The Piero della Francesca Memorial Chair Exhibition

October 6, 1990. It is still hot in New
Orleans, but there is a little breeze, a little
hint of fall coming. It's the first Saturday
night in October, the night when all the art
galleries in the city open their doors, trying
to get people to look at and buy what their
artists have been making over the summer.
The YA/YA gallery is decked out. There is
Fred's chair, on whose angular back he has
painted a voluptuous Venus de Milo. She
stands swathed in white robes, her face in
partial profile, gazing gently at her behold-
ers. There is a little miniature chair, only six

**Lionel Milton and Promosedia chairs,
Sansepolcro, 1990.**

Photo by J. Dexter Stewart, New York

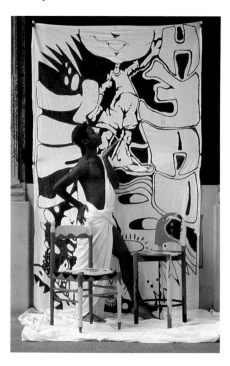

inches high, with the face of a de' Medici painted on it, and others adorned with the graceful stone arches, narrow winding streets, and lush foliage of central Italy. You wander through the gallery and there is a sweetness about the work and about the display—everything is so carefully placed. You notice the YA/YAs and their parents, little brothers and sisters running around the gallery, looking up at the chairs on pedestals and saying to their big brothers and sisters, "You made that?"

The show is a culmination of the YA/YAs' two months in Italy, documentation of their visit to the Renaissance, a time when people (men at least) emerged from the medieval darkness and began to explore themselves and their environment. Fourteenth- and fifteenth-century Italy gave the world a phenomenal number of gifted writers and artists. Their ideas and their art, which celebrated classical beauty, human potential, and education, literally shaped the future of the Western world. This is what the YA/YAs took home with them from Italy: knowledge of themselves, awareness of European art and culture, an appreciation for pasta and Italian ice cream, and the feeling of being respected for their creativity.

YA/YA Outreach: The Beginning

Trips to Austin, Los Angeles, Nashville, and Memphis follow, usually at the invitation of a commercial art gallery or a group working with youth. The YA/YAs travel to each

city accompanied by YA/YA staff, stay in people's homes, and do workshops with interested groups. In Memphis, YA/YA works with a Boys' Club; in Nashville, YA/YA has a booth in an outdoor summer festival. Commercial galleries offer to pay one-way shipping of YA/YA furniture, and the YA/YAs have to price their work so that if it sells they will receive a fair share of the proceeds, considering the gallery's cut and the individual's arrangement with YA/YA.

The next summer's trip is even more ambitious. Maybe because YA/YA set a precedent of going abroad that first time, or maybe just to see if we can pull it off again, YA/YA begins planning to take an even larger group to Europe in the summer of 1991. Debbie de la Houssaye, a very kind woman who works at the local French consulate, helps YA/YA to link up with a choral group in Aix-en-Provence, in southern France. The deal is that the parents of the young singers will house the YA/YAs for a week in return for YA/YA housing the chorus on its trip to New Orleans in August. Although we are not sure where they will all sleep, YA/YA agrees. Then the French government offers YA/YA another three weeks' lodging at the university in Aix if the YA/YAs will work with local children to paint a mural. An airline has promised plane tickets. The twelve students who want to go on the trip begin studying hard to get the B averages they need to travel with YA/YA. Everything is as ready as it ever gets at YA/YA (we even buy sleeping bags)

Darlene Francis displays Promosedia chairs, Sansepolcro, 1990.

Photo by J. Dexter Stewart, New York

when, about a month before the trip, the airline informs us that they will not be able to provide seats after all.

Everyone is crushed. YA/YA certainly doesn't have the money to buy plane tickets for twelve students plus chaperones. We ask advice from everyone we can think of and begin knocking on doors at various airlines, telling them our story and begging for free tickets. There are no takers.

Down and Out in New Orleans

A rainy Tuesday afternoon in May 1991. I am running around in an old blue raincoat, bringing YA/YA press packets to every airline in town, trying to convince them that if only they will fly YA/YA to Europe in four weeks, all their marketing worries will be over. They will be seen as such good guys that everyone will want to give them their business, and we will make them the "official airline of the YA/YAs" forever. Still no takers. Wet and dejected, I am standing outside the Hotel Inter-Continental, where a good friend and mentor, Dr. Carl Franklin, a retired, seventyish African American professor of management, plays jazz piano at four o'clock every day. I walk through the lobby, feeling the chill of the air conditioning, and there he is. "What's the matter, baby?" he says, looking at my sad face. I tell him my story. I tell him about all the YA/YAs getting their B averages. I look at him with pure hopelessness. He considers it for a minute, then he says, "Claudia, you

got to get those kids to Europe. You got to get on the phone." And he proceeds to tell me to call everyone I can think of who has money—especially the African Americans who appear on the society pages of the paper. He tells me to go get that money, to buy those plane tickets, and not to stop until I have enough to take all the YA/YAs. "Listen," he says. "There's a group that meets for breakfast at the Pontchartrain Hotel every morning at seven thirty. Friends of the mayor. They get together every day and carve up the city." He tells me the name of the leader of this pack and notes that it is only four thirty. "He's still in his office. You go back to YA/YA and you get on the phone."

A week later we have $9,000 in hand, enough to buy almost all the tickets from TWA, and since we are taking a group, they give us a free ticket for "lagniappe." People respond to our story. Sunny Norman, grande dame of the arts in New Orleans, makes a personal pledge and gets on the phone to someone in New York who leverages nearly half of what we need from a major corporation in New Orleans. The rest comes in smaller bits from individuals and businesses—gifts of $50 to $500. Since most of our food and lodging is to be donated, it is easy to justify spending a few thousand dollars of YA/YA's travel budget to make it possible for the whole group to go. Carl Franklin, and a few generous souls, have gotten YA/YA to Europe.

To Europe on a Wing and a Prayer

The trip begins in Italy. Jana goes ahead to Milan with six of the older YA/YAs to run press and visit contacts YA/YA made there the previous summer. One stop on their itinerary is the Mendini studio, top designers for such international clients as Alessi and Swatch, and certainly one of the most famous design firms in the world. YA/YA worked with Mendini to design a vase for the Alessi firm the previous summer.

It is a hot afternoon in June. Lionel, Sharika, Big Fred, Darryl, Dexter, Carlos, and Jana are walking the long city blocks of Milan, going from office to office, looking in windows and sweating. Two subway transfers, three more blocks, there it is, they've been here before. Up three flights of stairs, looking at the stone walls, touching their cool surface, finally they're there, into a huge room with many drawing tables and the famous Mendini designers hard at work. The YA/YAs sit down, two on the floor up against the wall, two under the circular staircase, two with their backs to the windows, waiting for the big man, Alessandro Mendini, to appear. They're waiting awhile. Jana is looking at the pictures of Mendini designs on the wall, gazing around, up to the ceiling, down to the tile floor, then slowly over to the faces of five YA/YAs sound asleep—everyone except Carlos. Darryl's head is down on his chest, Dexter's and Sharika's tilted up and back, Fred's and Lionel's to the side. And

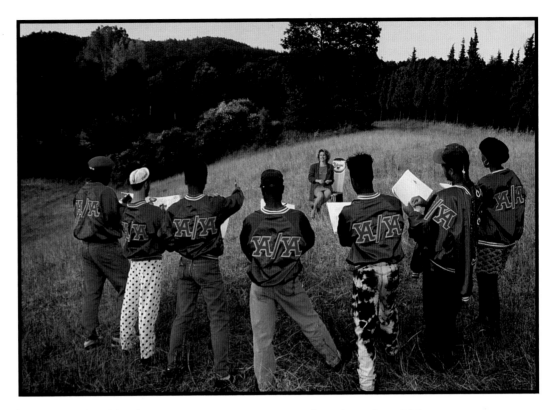

YA/YAs in Italy, 1990.

Photos by Charles Nes

here comes Mr. Mendini.

Six other YA/YAs and I take off from New Orleans a week or so later to meet the group. Although our destination is Italy, we must first fly into Paris—it is our least expensive option, since we bought tickets so late. We'll walk around Paris for a day, then take an overnight train to Rome. I am wondering what we'll do for twelve hours in Paris with jet lag and no place to go. En route, however, we are informed that the French air traffic controllers are on strike. We must be rerouted. I go to the counter: "Can you fly us to Rome?" No problem; the Italian controllers are working. One of the YA/YAs, making his first plane trip, is hesitant about checking his luggage. "How

71

much does it cost?" he asks. "Nothing," I say. He looks at me skeptically: "They take it and it don't cost nothin'. Right..."

Another day and four train transfers later, we meet Jana and the other six YA/YAs in a little town called Rieti, about an hour and a half from Rome. We stay in a monastery and visit the Vatican, the YA/YAs drawing and sketching their impressions of what they see. Rondell draws a beautiful oversized portrait of the Delphic Sibyl from the Sistine Chapel. He gives her African features.

The Swiss guards at the doors of St. Peter's Basilica in Rome stop some of the YA/YAs from touring the church because they are wearing shorts—while blond-haired German tourists who are also wearing shorts are allowed to walk right in. We take turns borrowing Jana's large scarf, tying it around our waists to make a kind of tunic so that everyone can go inside.

A brief stop in Sansepolcro allows the first-generation YA/YA Guild members to show their Italian home to the second generation. They roam the town, climb the hill to La Castora, the house where the YA/YAs stayed the previous summer, and shoot videos of one another romping in the forest.

Baptism by YA/YA

In many ways this is an induction rite. The first young people who came to YA/YA and traveled with YA/YA were the pioneers. They came out of curiosity and because

they saw an opportunity to make art and have fun. The second group—which included Courtney Clark, Rondell Crier, Freddie Johnston, Raheem Mahdi, Sharika Mahdi, Chris Paratore, Edwin Riley, and Eric Russell, most of whom were on the trip—knew the first group from school, saw what they were doing at YA/YA, and saw Jana and their friends on TV and in the newspaper. They wanted to get some of that for themselves. The trip to Europe is their real induction into YA/YA. They are accepted now, they are *traveling* together with the older guys. Sharon Riley, Edwin's mother, says of the second generation YA/YAs: "They came, they saw, they *liked*. They decided to conquer this! Because they weren't asked. No one said, `Come on and join.' They came in and they brought their chairs. They just came in and they took a spot and they started drawing and she couldn't tell them no because *they took it!*" The trip to Europe makes it official.

It is an induction of sorts for me, too. I had come to YA/YA in late 1990 and hit the ground running to raise money for the fledgling organization. Jana had promised to pay my salary for a year, but I knew I needed to raise enough cash to pay for myself and everything else much sooner than that. We were lucky to get major corporate underwriting within four months of my starting. It bought us some time to begin applying to all the usual sources of funding that require more lead time—grants and such—to pay for YA/YA's operating costs. So this

trip is the first time I am alone with the YA/YAs and responsible for them in a big way. And it is a baptism of fire.

After ten days in Italy, we start the journey to France to meet our host families and do our job working with kids in a French housing project. In Florence, where we stop on the last day to see a Botero exhibition, Jana announces that she is going on vacation for a few days. I am to get the YA/YAs to France. And, oh—there is also the matter of the six chairs and four small tables that we have picked up in Italy, artwork created the summer before and stored there. We should bring them along to France as well. "Maybe we could have a show," she says. I don't know what to say. All I can think is, How am I going to get all that furniture, twelve YA/YAs and their individual sleeping bags and luggage from Florence to Milan, overnight to Nice, transfer trains to Marseille, then on to Aix?

With the help of Mimi Landry, the teacher, who speaks Italian, I had purchased sleeping-car tickets back in Rome for the overnight trip from Italy to France. Good, I think, we're all set. Now all we have to do is get on the train. It is scheduled to leave a few minutes after midnight. The only problem is that nowhere in the gigantic Milan train station is there any indication of which track the train will arrive on. They haven't decided that yet. And the YA/YAs are traveling with enough freight to fill a small boxcar. I know that we will have only minutes to get on board. That would be fine except for the six chairs, four tables, sleeping bags, and luggage. "Okay, y'all," I say. "Everybody wait together here in the middle of the station. No, Freddie, come back. We've got to stay together. I'll try to find out what track it's coming in on."

The track is posted about a minute before the train arrives, and about four minutes before it will depart. The YA/YAs, Mimi, and I rush to load ourselves, the furniture, the luggage, and the sleeping bags aboard the three-block-long train, which has pulled in about five tracks over from where we are all waiting. "Just *get on!*" I tell everyone. "We'll find each other and our seats after the train pulls out." Thinking the hard part is over once the train is rolling, I find the conductor and show him our tickets for the sleeping car. He looks at me and at the tickets—and he looks really grave. "These tickets are for last night," he tells me in Italian. I hope I have misunderstood him. I look at the tickets. July 3. "This is July 3, right? I mean, it's been July 3 all day, right?" "Right, lady, until midnight, then it's July 4. The train left after midnight. You need tickets that say July 4." The sleeping cars, he tells me, are completely full.

We are lucky. We locate a couple of empty compartments—they seat six—and begin to get everyone settled. Mimi and I decide it is best to pile all of the furniture into one compartment, on seats and in the center aisle, and occupy it for the night. "Y'all stay together in this car, okay? Some-

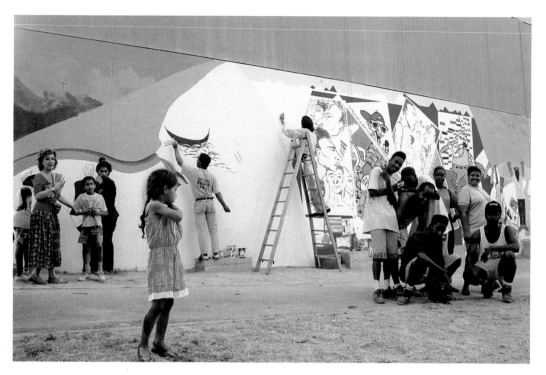

The YA/YA mural in Aix-en-Provence, France, 1991, with some of the children who helped the YA/YAs paint it.

Photos by J. Dexter Stewart, New York

times they disconnect cars during the night on a long train like this, and who knows where you'd end up. Really, they do that," I tell the skeptical YA/YAs. I feel pretty stupid about the sleeping-car tickets, but at least we are all together, everyone made the mad dash for the train and got on, and there are empty seats. Mimi and I crunch our bodies into fetal positions in the small space that remains unoccupied by furniture. Everything is fine, until about 3:30 A.M.

A loud knock. A young French conductor throws open the door, turns on the light, and stares in disbelief at us and the furniture. It is piled to the ceiling in the small compartment, chairs on top of tables, YA/YAs' luggage sandwiched in between. He says something like, "My God, what have you done?" in French, and we sit up

and blink.

I try to explain about the train, the last-minute crisis, the tickets that were issued for the wrong night. I show him the tickets. I show him my passport. I show him stuff about YA/YA and tell him about my students and their artwork and how we're going to France to meet families and how we just barely all got on the train. "C'était horrible," I croak, because at this point stress has taken most of my voice. He goes away for a minute. Mimi and I look at each other. He comes back, shakes his head, and says "Goodnight" in English, with just a hint of a smile. We curl up again and go back to sleep.

After another train transfer in Nice the next morning, during which three conductors scream at me about the furniture and I resort to tears, we finally arrive in Aix. Of course, the French families who agreed to house us have no idea that we are coming laden with furniture, but they get a van and, with much waving of arms and exclamations of a derogatory nature, figure out someplace to store the stuff. The YA/YAs, of course, are petrified about staying with

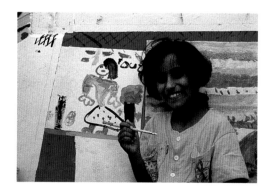

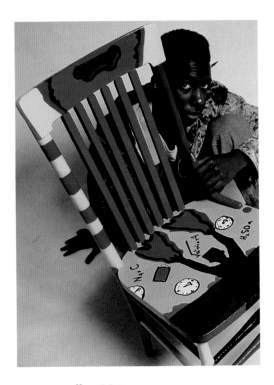

Eric Russell, 1991.
Photo by Michael P. Smith, New Orleans

mural site and holding watercolor classes outdoors with French children of Moroccan and Tunisian descent—beautiful little kids who speak perfect French but are discounted by the European French because they are people of color. We learn that when you ask children to paint a picture of their hopes and dreams, they tend to draw the same thing—a house, a sun, a tree, flowers, a family—the picture of security, whether they are French or American or Japanese. It is a project that transcends age and language. The YA/YAs take the children's images, add some larger cartoon elements, and combine all of this into a mural. The children help paint the mural, transferring their individual watercolor pieces into little square spaces on the wall using latex paint, the YA/YAs working alongside them. Someone plays a drum for us. A big friendly dog comes to watch.

people who, for the most part, speak little English. But I am just very, very happy to be off the trains.

YA/YA in France

It is the light that is so special in southern France. It is the reason that so many artists, particularly the French impressionists, chose to paint here, to capture that luminous blue and pink that comes from the evening sky and makes everything look rosy and soft. The intense summer heat gives the landscape a stillness not unlike that which is captured on canvas. The place already looks like a painting.

Our work in Aix consists of going to a

Watch Out, World

The Europe trip is everything it was supposed to be. We think back to our conversation with the gentleman in New Orleans who said, "Why take these kids to Europe?" The journey opens the YA/YAs' eyes to other cultures. It brings YA/YA recognition (we will get good commissions from this trip), and it gives the YA/YAs the opportunity to be teachers. Being invited to share their skills with others validates their work, to other people and to *themselves*. It also helps everyone—YA/YAs and adults— to grow up. Courtney Clark says, "I think

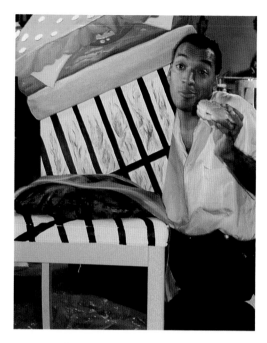

Burger King commercial set, 1991, chair by Carlos Neville.

Photo by Michael P. Smith, New Orleans

that's where we learned how to communicate with each other. If we didn't get along it was going to be rough."

Sharika Mahdi remembers how the trip influenced her college studies. "After I started taking art history classes, it was amazing, because I *knew!* I'd be totally fascinated with everything on that slide show. [I'd see] ancient Rome [and think] 'God, I was standing on those steps!'" Chris Paratore tells how he shared his travel experiences with his friends back home: "They'd get a map and they'd show me, like, 'Where you was?' and I'll point out where I was and tell them how it was and how it looked and what I saw and what I learned. 'Cause they haven't been there, and I know most of 'em won't get there. It's not like Uncle Sam's gonna give you a gun so you gotta go. I went on my own, and that's what they liked."

Because the organization saw the importance of travel and was willing to invest in it, the YA/YAs became associated with travel and outreach in other cities. One result was that, even early on, people began to pay us to travel. The next major European trip, to Holland in 1992, was completely paid for by the De Bijenkorf company, which contracted with YA/YA to paint and perform in its department stores. A trip to Japan in early 1993 was financed by an art broker, who paid not only travel costs but two-way shipping on a container full of YA/YA furniture.

The YA/YAs routinely travel around the United States doing various jobs for commercial entities, and while they are in each city, with travel costs paid (either by a client or by Philip Morris Companies Inc., the underwriter of YA/YA's Outreach Program), they work with other nonprofit groups and visit colleges. The result is usually a happy match between a YA/YA and a school or an internship, valuable experience for the YA/YAs in working for commercial clients, and new friends who continue to serve as useful contacts for YA/YA.

Listening to Other People Talk

Another great benefit of travel is that it provides a basis for comparison. Jana explains it: "You don't know whether you're short or tall; you only know whether you're short or tall in New Orleans. You go to Guatemala and we're all real tall. It's the same way with words. You don't know how distinctive yours are till you listen to somebody else's. That was real important to me because I was trying to make you find yourselves as individuals."

Travel is also about self-confidence: faith in one's ability to move around in the world. And this confidence can only be gained by doing.

July 1991. Lionel Milton and I are standing in a line at the train station in Nice, waiting to buy him a ticket to Paris. The Burger King Corporation has agreed to fly him home to New Orleans so that he can act in a commercial they are doing

with the YA/YAs and then back to France to rejoin the group. It is a long line, and when we finally reach the counter we must find a train that will get him there on time to make his flight, that pulls into a station from which it is easy to transfer to the airport, and so on. Lionel looks at me at the end of the transaction and says, "I never realized it was so complicated. So this is why it takes you so long to get all the train tickets and stuff." I am not sure how he is going to find us in Aix. We're not even there yet and no one has told us the address of the dorm where we'll be. So we say good-bye to him and tell him to check for instructions at the YA/YA office in New Orleans. We'll call when we know something. We do call home when we arrive in Aix, but the instructions are complicated and Lionel has never been to Aix or the university where we are staying. The buildings are numbered in a seemingly random fashion and of course there's a switch at the last minute from one building to another, and of course Lionel has already left New Orleans.

A few days later, one evening in Aix, I am walking back to the dorm with a few of the YA/YAs. Suddenly up ahead we see a familiar face: Lionel, grinning from ear to ear under a purple hat, toting his knapsack on his back. He has managed to fly home, star in a commercial, return to France, and buy a ticket for the right train to Aix. He

took those directions we left with Walter, asked around town in his jive new French, and got himself pointed in the right direction. On the way to the university he ran into some of the YA/YAs, and here he is. He is eighteen years old, the world belongs to him, and he knows it.

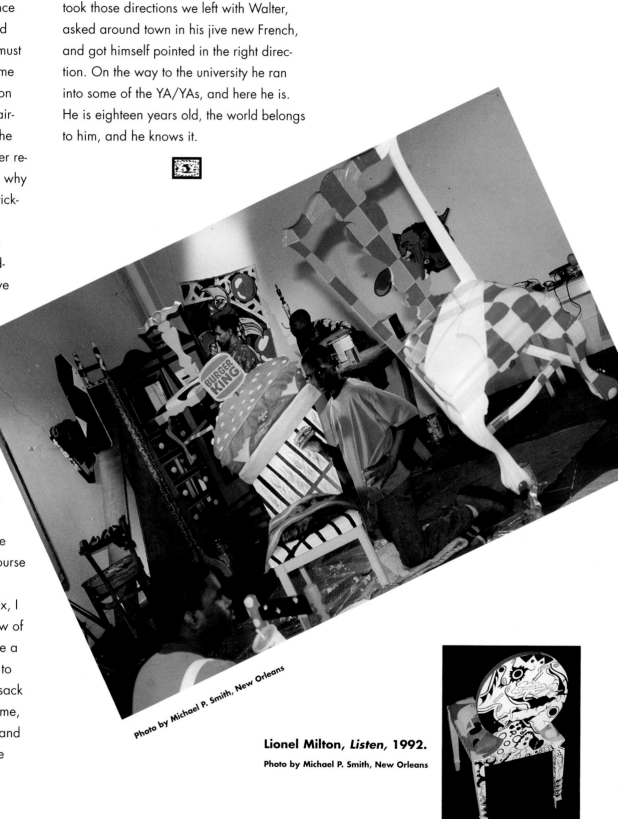

Photo by Michael P. Smith, New Orleans

Lionel Milton, *Listen*, 1992.

Photo by Michael P. Smith, New Orleans

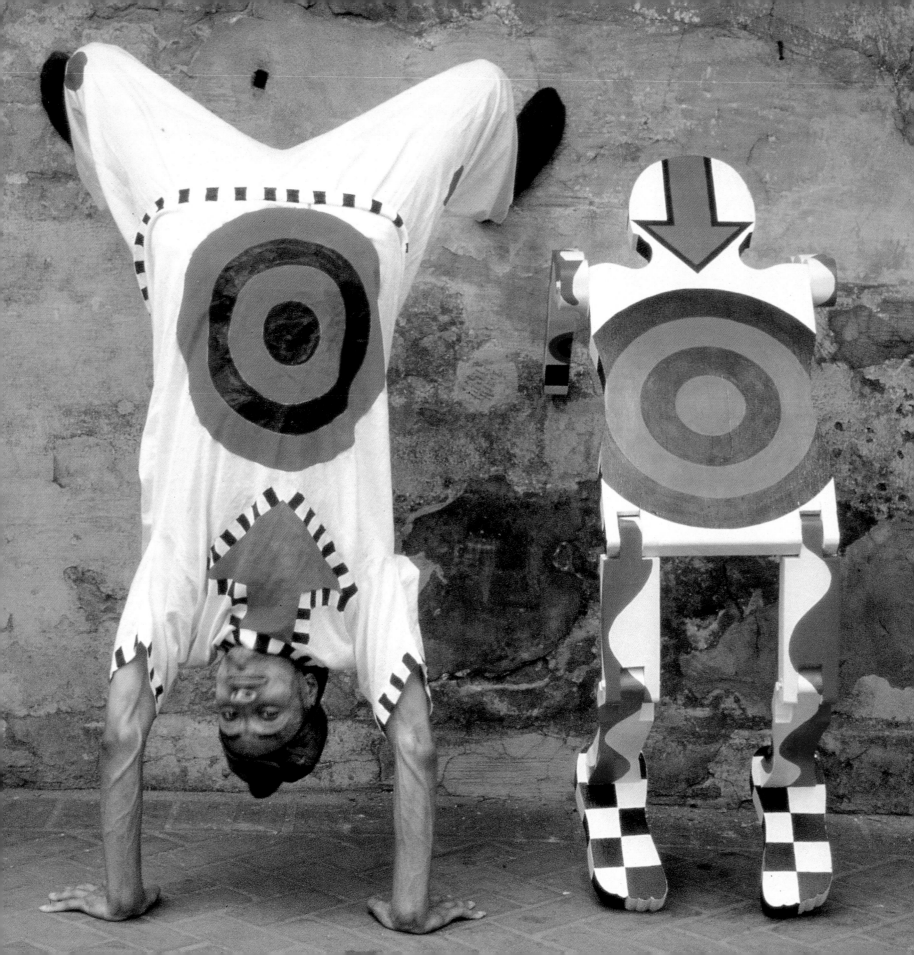

chapter 5
REWARDS
(And How to YA/YA in Your Neighborhood)

ONEY drives everything and everybody in one way or another. For the YA/YAs, as for most young Americans, money is what is real. It is tangible. It is new clothes or art supplies or tuition for college. It is also a sign that somebody values you and your work. Darlene Francis says money is a part of the reason new students come to YA/YA: "It's an important factor because every one of these other people must think, `Wow, if I did real good like that and...made some strides, too, I could get money and I could get a lot of recognition, too.'"

Then there's the other side of the coin: after students have become invested in the organization, generosity flows from them at odd moments.

August 1993. The YA/YAs are spending a couple of days at a retreat center in the country, talking about YA/YA's past, present, and future. At one point I ask how

they see themselves and YA/YA in the future. Eric Russell says he wants to keep doing art but really wants to be a rapper and make lots of money. "I plan to have my demo tape by next summer comin' up, and I'll have a ticket bought already, so I'll go up north and get my little record deal, and once I get the record deal...I can give money to YA/YA so you won't have to get no more grants."

Money. Money links us and divides us more powerfully than anything else in our lives. At YA/YA there are great disagreements about money—about how important it is to the students, about how much of it should be spent to support the organization, and about who should be paid how much and when. And the basis for all the confusion and furor over money is fear. Fear of not having enough, of having to share, of somebody else having more, of being *undervalued.*

Worth = Worthy?

Part of the problem is that we let the amount of money paid for a job or a piece of artwork stand as an indication of its worth, or the worth of the person doing it, when all it really indicates is what the market will bear. Because of the value society places on money, young people often see it as an end in itself, instead of as a vehicle to something else. Worse, they begin to use money as a means of self-evaluation. It becomes part of the face in the mirror.

I ask some of the YA/YAs what they

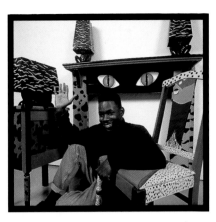

Living room by Lionel Milton, 1990.
Photo by Michael P. Smith, New Orleans

(left) Carlos Neville and his target table, 1993.
Photo by Michael P. Smith, New Orleans

were thinking as they painted cloth appliqués, based on the themes of trust and fairness, that would adorn the slipcovers that YA/YA was creating for the United Nations in early 1995. It was a job of international significance and certainly the most prestigious YA/YA has ever had. One of the YA/YAs frankly replies, "I know what I was thinking about: getting ten dollars apiece for each one."

When asked whether it is money that motivates students to come to YA/YA in the first place Sharika Mahdi says, "It's more than just one factor. You can't say it's solely money." Rondell Crier says, "I probably woulda came anyway even if there wasn't money involved. But I heard Miss Neske say you can make this amount of money at YA/YA if you sell a chair. It motivates you."

Usually high-school students come to YA/YA out of curiosity and the desire to do artwork. They begin to make a little money by selling a piece here and there. Then they get older. Their responsibilities increase—they need to pay for their clothes and senior rings and proms and dates. The "Oh-my-God-I-gotta-get-a-job" syndrome hits, and they start looking at the time they spend at YA/YA. They think: Is it worth it? Should I go out and try to get a steady job bagging groceries so I can get a regular paycheck? They know that if they paint a chair they might make the equivalent of fifteen or twenty dollars an hour—if it sells. But they were raised to view regular, steady employment as a goal for them-

selves, whereas YA/YA tends to encourage self-employment and entrepreneurship.

"There are no jobs out there," Jana says. What she means is that there are very few jobs that allow people to make good money using their creativity. But most people would consider that a luxury. So why does YA/YA insist on training people to be entrepreneurs? Because the skills needed to be in business for yourself are skills that can get you far in life, whether you are working for somebody else or not. Those skills include talking to a customer and finding out what he wants, setting a price on your work, making sure you get it done on time, and collecting the money. YA/YA tries to develop those skills in the students with every job that it does.

Chris Paratore comments on how new YA/YAs feel about their earning potential at YA/YA: "Most of 'em know it ain't a guaranteed gig. I mean some of the first artwork, it can stay there for a month"—not selling, not netting the YA/YA any money. What to do? Keep at it! The transformation between a new YA/YA and the same person one short year later is nothing short of phenomenal.

"What do you need all that money for?"

Developing the skills to make and sell art is hard enough. Understanding the role of money in the larger realm, that of YA/YA the nonprofit organization, is even harder.

Fall, 1991. YA/YA is hosting one of its

first group meetings with the YA/YA parents. There is an undercurrent of wariness, of free-floating mistrust. We talk about the program for a while, answer some questions. Finally one of the mothers says, "So what happened to all the scholarship money?" "What scholarship money?" we ask. "All that money that y'all were supposed to get for our kids!" We look at each other a little bit confused. Then Jana remembers. When she first conceived the idea for YA/YA, someone had told her it would be possible to get money for scholarships for the YA/YAs. She must have mentioned this possibility to the parents of the very first group of YA/YAs, way back in the beginning. After the organization was incorporated and got its nonprofit status, however, she found out how complicated it is to raise and distribute scholarship money to a group of people who come from only one school. Issues arise about equal access, especially if any of the money is from the federal government. Since she was an artist, it seemed like a much better idea to offer the young people training so that they could make something and sell it. Although YA/YA occasionally helps someone by providing airfare for an internship in another city, and once a year YA/YA gives a $250 grant to a deserving high school student, there never was any money that came into YA/YA specifically slated for scholarships, not one penny. Lots of talk follows. Some of the mothers thought that YA/YA—or Jana—had gotten money for scholarships and

kept it!

In the beginning, the YA/YAs knew very little about the cost of running an organization, so they did not understand what money was used for when it came into YA/YA. The YA/YA parents had the same problem. The only solution was to share information, to educate the whole YA/YA family about the organization's finances. It is an ongoing process, but one that is vital for peace and harmony. Once the YA/YAs know that it can cost up to $1,000 a month to air-condition the space, and they make the connection that the money could be used for something more fun than paying the utility bill, they begin to remember to close the door, at least sometimes.

The Price of Education

Doing a program like YA/YA—one that offers *extraordinary* opportunities to young people—is expensive. Depending on the year and the number of people directly served, the organization might spend from $10,000 to $18,000 per student each year to run the program.

Rondell Crier says, "Why don't you just give me the eighteen thousand dollars?" The answer: That money would not come to YA/YA to send Rondell Crier, or anyone else, to a nice school or buy his clothing or send him on a trip. That money comes to YA/YA, in the form of grants and contributions, to run a program that serves not just the twenty-five young people YA/YA sees every day but that also serves as a model

for all of those people who call YA/YA and ask, "How do you do it? Can we do it in our community? Can you tell us how?"

Part of YA/YA's reason for being is to do just that—to share what we know with other people, to show them what has worked for us, and what pitfalls they might avoid. So, if we were to take YA/YA's expenses and divide them by the number of people the program *touches around the nation and world,* we would get a very different cost per participant indeed.

The problem comes when people—observers of the program, funders, politicians, educators, whoever—try to put YA/YA in a cardboard box, seal it up neatly with masking tape, and label it: "social service organization" or "arts organization" or "job training program." Then they get out their handy chart of program costs and they determine just how much one of these should cost to run. And when they look at YA/YA and they compare it to their little chart, they think YA/YA spends a lot of money.

It's true. The question, however, is not how much money an organization like YA/YA spends, but whether what we spend it on is worth it. Take seven students to a little town in central Italy where no one has ever heard the word *nigger* and they become stars. They come home with a different picture of themselves. Take twelve students to France to work with little children in a housing project and they become teachers. Teach twenty students how to design and print fabric, involve them in the

marketing decisions, and they learn how to run a business. These are the kinds of opportunities that investment in young people can buy.

"Okay, but just don't be too successful."

During my tenure as YA/YA's director, we fielded many questions about YA/YA's budget, cost per participant, and success in attracting both contributions and contracts to provide services. What is often implied in such questions is that there is something suspect about an organization that is successful in getting grants and earning money for its own operation.

Why? Because this kind of success is threatening. It throws the question of how much we should spend to educate our young people directly into the faces of the people in charge. It says, "Look at what kids can do if given the opportunity," to the very people who have traditionally denied them that opportunity.

YA/YA's success also challenges the belief that nonprofit organizations must exist on shoestring budgets, their cash flow dependent on the kindness of their donors and the timing of their grant payments. Most small organizations do exist this way, often struggling to make payroll every two weeks. Does this make them more altruistic than YA/YA? No, it just makes them poor. And poor means vulnerable.

The salability of YA/YA students' work is also threatening on another, more basic

level. It forces older, established people to share, and sharing the market with young people is never easy. Like all small enterprises, YA/YA is trying to grab a piece of the pie. And the people who are used to eating their fill of it resent the intrusion.

The Search for Money

August 1992. I am at the Greater New Orleans Foundation talking to the staff there about people who could help YA/YA get its fabric workshop up and running. Terry Weldon, a nationally known sculptor and print maker, has approached YA/YA about developing the workshop as a training vehicle and revenue generator. The foundation director, Ben Johnson, and two women who work for the foundation, Linetta Gilbert and Carolyn Sonnier, are brainstorming about whom YA/YA might approach. They give me some good leads and I go home and start writing.

I send a letter to a lady I've never met but who I've heard is committed to causes benefiting youngsters. I ask her for $10,000 to help us build the workshop and pay for an artist to instruct the students in fabric design. A few days later she calls. She is very kind to me on the phone, but she also says, "This is an awful lot of money for you to ask me for when I've never met you or supported your organization." I tell her who we are and what we do. I explain that the fabric workshop idea came about because we want our organization to become more self-supporting—

"Like we're teaching the students to be," I add. "And so that's why I came to you. Check us out. I think you'll find we do good work."

She calls again the next day sounding very happy and excited. She says, "I've decided to give you the money. The full amount you asked for. Just don't come to me next year and ask for this kind of money again! This is a one-time gift, okay?" I can't say very much because I'm crying. I thank her as best I can and get off the phone. Walter looks at me. "Aw, you didn't get the money?" he asks. "No, we did! Ten thousand dollars!" He cocks his head quizzically. I can't explain my feelings at that moment.

September 1993. The official opening of Print YA/YA. The gallery is decorated with fabric swatches, and we have roast beef and sweet things to eat and drink and a wonderful piano player from one of the churches. We have invited all of the people who gave us money for Print YA/YA—the lady donor, Mr. Blumenthal, people from the Downtown Development District, the National Endowment for the Arts, the Mary Reynolds Babcock Foundation, New Orleans Public Service, Inc., Freeport-Mc-MoRan, Inc., the RosaMary Foundation, and the GPOA Foundation. Contributions from these people will later help leverage more money from the Charles Stewart Mott Foundation.

We are so proud of the pillows and the yardage that the students have printed and

displayed all around. The YA/YAs are dressed up and bubbling over with pride. The turnout is slim, but we are having a good time celebrating anyway, and it is still early. Two petite older ladies come in the front door. I sort through my mental list and I just know who they are even though I have never seen them before. I walk up to them and say a name. One of the ladies, in a simple pale green dress, nods and smiles. Our $10,000 donor. She introduces me to her sister, whose arm she is holding onto. I walk them through YA/YA and the print shop. They talk with some of the students, marvel at the work, and compliment us sincerely. I tell the donor that her contribution meant more to me than almost any of the others because she took such a

YA/YAs with Print YA/YA fabric, 1994.

Photo by Jana Napoli, New Orleans

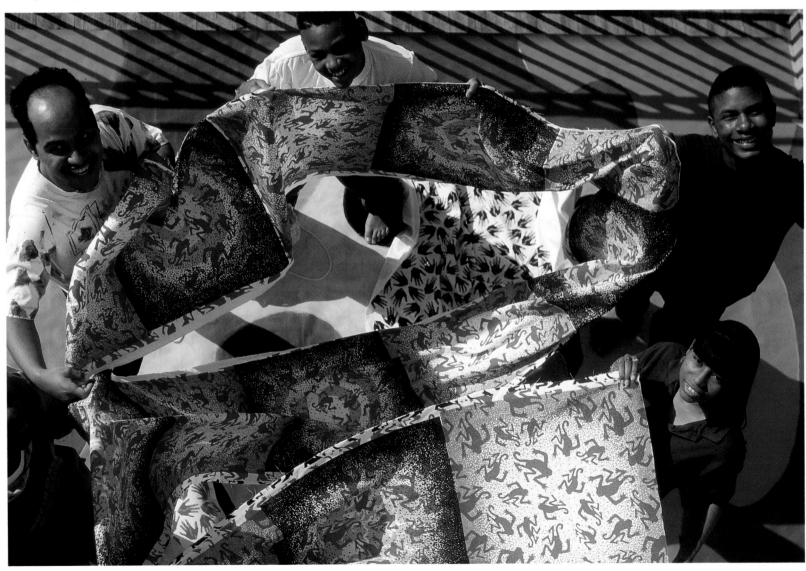

chance with us—she didn't know us but put money on us anyway. "Oh, I asked around about you. And I peeked in the front window, too" she says, smiling at me. I watch as she and her sister walk arm-in-arm out of the gallery. They get into a modest station wagon and make their way slowly and carefully up Baronne Street.

People Give to People, Not Causes

November 1990. I have just become the first director of YA/YA. My job in life is to find money so that YA/YA can continue and begin to spread its mission around the nation. I think about it day and night. Jana has provided seed money for the organization's first year and a half, but I must come up with money for its future. I call a friend who is a fund-raising consultant and ask her who is giving money these days. She says, "Well, Philip Morris just gave $100,000 to a program I'm familiar with." I start writing. I tell Jana we should approach Philip Morris. Both of us start talking it up, asking around to see if we know anyone who knows anyone who can get us in the door.

A week or so later Jana goes to a big party. She is introduced to a tall, dynamic man named Stanley Scott. She reads his palm and tells him stories about himself. He laughs deeply and gestures expansively, a big man with a big heart. She learns that he is the owner of the local Miller beer distributorship, a subsidiary of Philip Morris Companies. "Oh, God!" she says, "We're

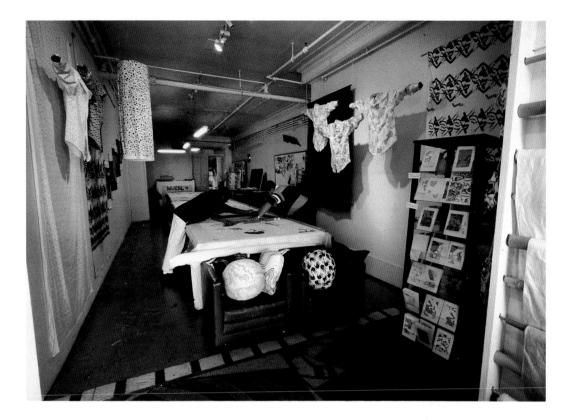

Print YA/YA fabric-printing workshop.
Photo by Michael P. Smith, New Orleans

trying to approach Philip Morris for money for our program." And Stan Scott, whose long list of achievements includes having been a top executive of Philip Morris, takes that large, generous hand of his and opens the door for us.

A couple of weeks later Jana and I go to New York. We visit Stephanie French, Philip Morris' vice-president for corporate contributions. We show her pictures of YA/YA work and tell her about the importance of taking the YA/YA students and their artwork to other cities. We propose visiting several places, most of which have a Philip Morris presence, such as a manufacturing plant for one of its subsidiaries—for example, Kraft foods. She is obviously

Brandon Thomas, 1995.

Caprica Joseph, 1995.

Edwin Riley, 1995.

Gerard Caliste, 1995.

very busy, but she is also warm and welcoming. She is very fond of Stan Scott. She promises to consider our request.

A few weeks later I get a call from Stephanie's colleague Anne Dowling. We are a small, unknown organization, and she is a top executive with one of the largest multinational corporations in the world. Yet she is solicitous and respectful in her questioning about our program and this particular project's budget. She tells me, "It looks good," and promises to be in touch.

February 1991. Anne Dowling calls and asks if it is okay to visit YA/YA. Will there be anything special happening on the weekend of March 2? In fact, I tell her, we will be unveiling a large mural that the YA/YAs were commissioned to do for a local shopping center. We'd be thrilled to have her.

March 2, 1991. Anne Dowling arrives with a check for $75,000 to underwrite YA/YA's Traveling Exhibition and Outreach Program. She attends the unveiling of the mural, along with the mayor of New Orleans and other city officials. She meets the students and spends some time with Jana and me. We feel we have made a friend. Over the next several years we call upon her for advice and counsel, about getting funding for YA/YA, not only from Philip Morris, but from other entities as well. It is her world and she is willing to share it with us. She offers us great gifts and asks for absolutely nothing in return. Philip Morris continues to be a major spon-

sor of YA/YA's Outreach Program to this day.

Raising Money

There are limited funds available, no matter how good your project. When YA/YA goes out asking for money, we always go in pairs or groups of three. One person talks, one listens, the other watches. What one of us misses, the other might pick up. Two or three brains working together make a good team.

As the primary fund raiser for YA/YA, I often feel like a packhorse carrying loads of gravel up a steep trail, with a gadfly buzzing in my ear, "You'd better succeed— or else," over and over again. Before the organization began attracting large commercial jobs, and still to some extent, whether YA/YA could pay people their salaries or not depended on my success or failure.

After the first two years of touch-and-go fund raising, YA/YA begins to operate with its sights focused a year in the future. We try to always have cash in the bank to cover the current year's expenses, so the proposals we are writing today will generate funds for next year or the year after that. This is why earned revenue is so important to YA/YA. We are extremely lucky with the first grants and contributions, but we never know how long our luck will last—maybe youth programs will become less fashionable with funding sources. So we treat the grants as if they were small-

business loans that we don't have to pay back. We use the resources available to *create a structure* that allows us to begin earning our own way.

One mistake we make is not involving the YA/YAs in the money raising from the beginning. When I first arrive, I am so concerned about the lack of money that all I do is write proposals. I almost don't notice the YA/YAs. It isn't until much later, when we have some money in the bank and I feel YA/YA is on safe ground, that I begin to realize what an asset the YA/YAs could be in fund raising. After all, the program is by them and for them and about them. Later, when prospective donors visit YA/YA, I always give them the opportunity to talk with the YA/YAs—alone, if time permits—so that they will have a clear picture of what YA/YA is all about. Then when they give us money, they know who they are giving it to.

It is equally important to involve the YA/YAs in the stewardship of that money. Again, we are late on this one. It is only now that YA/YA is teaching the YA/YAs to read financial statements and involving them in decisions about how we spend money. If our goal is really to turn the organization over to the young people we serve, they must learn, as we learn, how to manage resources.

This is the formula that has worked for YA/YA: Seek sources of funding that fit YA/YA's mission, call them up and establish a relationship with someone who can help

guide us, and write a letter or proposal asking for what we need to run *not the whole organization, but a specific project.* Fortunately for YA/YA, the organization appeals to several different *types* of funders: those interested in supporting arts programs, those interested in funding programs that provide social services to youth, and those interested in funding programs that teach job skills. The more holistic your mission, the more funding sources you will attract. The more varied your program, the more funders' guidelines you will fit.

Where There Is a Need

It was no accident that YA/YA came onto the scene at a time when many corporations and foundations were seeking to support programs that benefit urban youth. Many funders had arrived at the same realization as Jana: that many youngsters who grow up in cities have been underserved—not offered the opportunities that previous generations enjoyed. Private foundations in particular, possessing the money and the wherewithal to gather and analyze current information, turned their attention to the challenges facing youth in the mid-1980s. They discovered that most urban youngsters are not being trained to support themselves. Some of them are not even being trained for basic survival. YA/YA's mission of helping prepare young people to become economically self-sufficient appeals to a fairly broad spectrum of funders on several levels.

Gerard Caliste, *Fear,* 1995.

This is what funders like: First, programs that teach people to fish rather than just treating them to a fish fry. YA/YA develops young people's *skills* so that they can eventually employ themselves by making a product or providing a service. This approach requires a more extensive investment, but it pays greater dividends in the long run.

Second, funders look for programs that have built into them a continuous means of support. YA/YA has created an industry that will be operated by the young people it was designed to serve. And that industry will generate revenue that can help support the program. One of the biggest concerns on any funder's mind is how an organization will be able to sustain a program after the seed money runs out. YA/YA's potential for earned revenue is a plus.

Third, funders like programs that get good press. People who make funding decisions must report to their shareholders, their supervisors, their boards of directors. It almost does not matter whether the funding organization is even mentioned in the newspaper or magazine as being a supporter. Funders enjoy being associated with a winner, a high-quality program, no matter how small, that merits attention in the press.

How to Start: The Grants Game

You start small. Or you start medium-sized if you have a funding source that is willing to offer you a lump of seed money. Whatever you have, it is probably enough as long as there are people with vision and passion who are willing to work. You might create a small program that serves six students for two hours each day. You approach a church or a school, where there is likely to be an organized pool of young candidates, and you offer to provide a limited number of them with a particular kind of instruction for a specific period of time. Once you have this up and running, you write a description of what you are doing. Boom! You have a program. You give it a name and you decide how you would like to see it grow. What should it look like in five years? Once you have a clear vision of what you want your program to be, you are ready to raise money for it.

There is nothing mysterious or magical about raising money. Grant proposals are simply a description of what you want to do and how much it is going to cost. They can be very short—two pages of text, in the form of a letter that outlines your project, with a brief budget attached. A budget consists of a list of your revenue sources (money that you expect to come in) and your expenses (money that you expect to spend). Each line of the budget describes a specific source of funds or a specific kind of cost. For example, your revenues might include five line items: individual contributions, corporate contributions, foundation grants, government grants, and earned revenue. Your expenses will be much more varied and interesting. They might include salaries, art supplies, artists' fees, utilities,

Gerard Caliste, *Ruff Ruff*, 1996.
Photo by Michael Eder

88

space rental, and equipment. Or they might include shipping, insurance, legal and accounting services, postage, printing, and telephone. Whatever your expense categories, you have to make sure they include all the costs of your project. And you had better not plan to spend more than you plan to take in.

Most funding sources do not require voluminous proposals (although some do). They can determine if they are interested in funding your group by reading two or three pages of project description. They can determine if your costs have been thoughtfully considered by reading your proposed budget. If they are interested in your project and need more information, they will surely ask for it. I have found that it is best to call a funding source for guidance on how to apply, send a written proposal using those guidelines, and then follow up with a phone call to make sure they received the package and to determine if they need anything else. This strategy also gives you the opportunity to establish a working relationship with someone at the funding source, which can be very helpful.

Usually the guidelines for proposals are very specific. They might require, for instance, a project description that "does not exceed five pages, typed and double spaced, with one-inch margins." Often funding sources will include a budget form that shows you which costs are "allowable," that is, which types of project costs they will fund.

Some funders will not allow their money to be spent on some specific kind of cost—for example, administrative salaries. This restriction does not mean that your project cannot have any administrative costs; it just means that you may not spend grant money from *that source* on administration. So your administrative salaries must be covered by some other source, even if it is your organization's general funds—those raised from undesignated contributions, usually from individuals or corporations. In some instances funders will know your program so well and believe in your mission so much that they will give you a grant and tell you to spend it on whatever you need most. Use these funds to match money received from funding sources that *do* care what budget line items their money pays for.

Most funding sources want you to match their contribution with other money. Few funders like to be the sole source of support of any project. They like to know that if they are unable to renew support of your project, other sources of funds exist that your organization can tap to keep the project afloat. Funders also like to know if your project could become self-sustaining— is there a potential for earned revenue built into it? If there is, tell them about it in your proposal.

Ready, Set, Go Where?

How do you know which funders to approach? You remember the number one

rule in fund raising: People give to *people*, not to causes. So your very first task is to gather everyone involved in your program (staff, board, volunteers, students, parents, neighbors, and friends—the program's "family") and make a list of any funding sources with which *anyone* is connected. Perhaps a staff member has a neighbor who works for a large corporation. Or maybe one of the parents knows someone who is on the board of a private foundation. Once you have scanned everyone's memory banks for possible linkages, both inside your own city and nationally (politicians count!), the next step is to approach these people. Ask them for money? No. Ask them for *guidance* about how to get money from the corporation, foundation, or government program to which you would like to apply.

It is important to remember to be brave. The worst thing that can happen is that you will be told no and have exactly as much money as you had before you asked. And maybe just a slightly smaller ego. In all probability, however, some of your requests will result in a donation. And the feeling you get when someone decides to believe in you and in your program enough to fund it is awesome.

Gifts in Kind

It is not only money that makes YA/YA run. The training and travel opportunities YA/YA offers would be impossible without an abundance of nonmonetary contribu-

tions, ranging from the gift of Jana's time to sleeping space on the floor of a friend's apartment in a far-off place.

June 1991. Jana is in Paris with six YA/YAs, a two-day stopover in a mad dash between Milan and Aix-en-Provence. They are staying at the apartment of Alexandra Monett, a red-headed New Orleanian with an infectious laugh who makes her living dealing art on two continents. This summer Alexandra has a place overlooking the apse of Notre Dame Cathedral, an enviable spot from which to see and hear Paris' rhythmic bustle and loud bells. She and her roommate are happy to share it. All six YA/YAs and Jana crowd into the apartment, sleeping bags strewn all over the floor—Big Fred finds a spot to sleep under the dining room table. Alexandra is running around, cooking chicken in the oven, trying to make sure there is enough of everything for everybody. So there is one small bathroom for nine people? So what! The YA/YAs are in Paris.

The next stop is a small village in Holland where Jana has taken the YA/YAs to meet a friend of Alexandra's. They are supposed to stay one night, but on the way up Fred gets sick. Alexandra's friend Else, who is hosting the group, graciously keeps all seven travelers for two extra days.

July 1991. Thirteen YA/YAs and three chaperones come together in a little town called Rieti, outside of Rome. We are staying for cheap in a monastery. Father Cesare—a friend of the priest who runs the

monastery—attired in a friar's brown robe and sandals, and his mother, Sylvia, a vivacious Italian friend of Jana's from New York, arrive one evening with pasta bolognese for sixteen, complete with fresh green salad, crispy bread, and even paper plates and napkins. We eat sitting on the floor in the hallway, talking about church vestments, Rome, and the significance of deep purple.

July 1992. YA/YA is playing host to forty high-school students—all of whom are bouncing off the walls, jumping up and down, and eating everything in sight—for a six-week summer job-training program. The kids are in heaven. Happy and loud, they feel loved and cared for at YA/YA: hot meals at noon, lots of attention from instructors—plus they are getting paid! The aim of the program is to expose the students to the art and culture of many different lands and to loosen and shake free the creativity that is within each of them. It is an ambitious task, and YA/YA has asked many friends to help. Asian dancers, a group of Japanese chefs, an African American storyteller, artists from Jamaica, all come to share bits of themselves with the students. Most of them work for little or no pay.

One week is devoted to India. Ms. Neske shows slides of the Taj Mahal, glorious mountaintops, sacred cows in the cities. YA/YA's instructors teach the students how to print fabric with exotic designs that look and feel Indian. We decide that the week would not be complete without a real Indian meal, so we call the Taj Mahal restaurant, tell them about YA/YA's program, and ask if it would be possible for the students to get a taste of India. The owners of the restaurant offer to host the entire group of students and teachers for lunch, absolutely free of charge.

Friends of friends; someone's brother-in-law; the woman who works at the French consulate who puts YA/YA in touch with the singing group in Aix-en-Provence, and the one who works for the Italian consulate who makes phone calls to monasteries; the people who drop by and bring us a piece of furniture "so the kids can paint it"; the psychologist who gives us hours of his time explaining the mysterious workings of organizations and making suggestions about how to keep our sanity and give the best of ourselves to the YA/YAs; the educational consultant who normally makes over $1,000 a day but charges nothing to assess the YA/YAs' and staff members' individual learning styles so that we might all understand our strengths and weaknesses; Benjamin Moore, the paint company, which gives us two hundred gallons through its distributor, Helm Paint; the woman who works for the Architects and Designers Building, where YA/YA has a show in New York, who houses and feeds the whole group for a week at her parents' house in Scarsdale; and the one in San Francisco who does much the same thing: All of these people, and many others, make YA/YA possible. For them, YA/YA is an in-

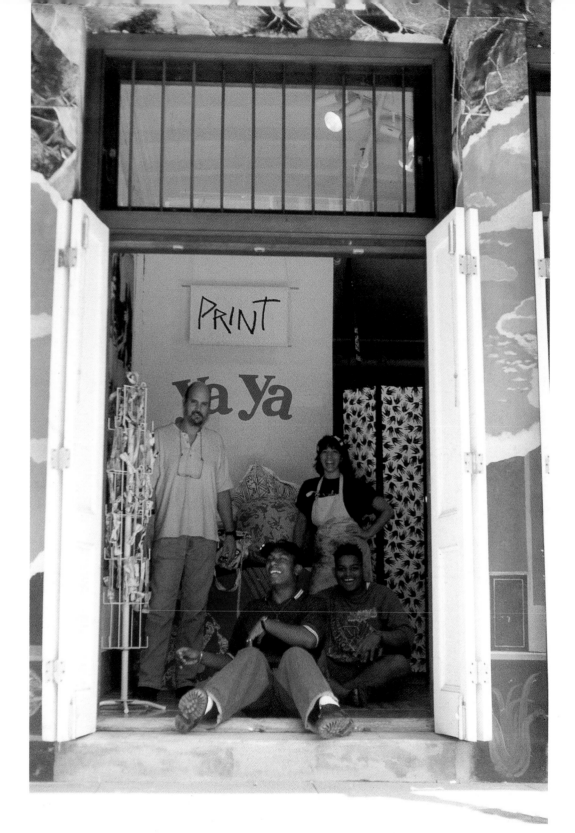

Print/Design YA/YA creative director Terry Weldon (standing), Print YA/YA production manager Maria LoVullo, and YA/YAs Tarrie Alexis (left) and Brandon Duhon, 1996.

Photo by Edwin Riley III

spiration to move in directions that they might not otherwise take, to shake up the planet a little bit and rearrange the pieces so that a young person can have something special. For YA/YA, they are our cheerleaders, our extended family, our friends. We wouldn't be anywhere without them.

Making Art, Making Money

YA/YA's reason for being is to help talented young people become economically self-sufficient. That is the reason for all of the training, all of the travel, all of the special services. YA/YA wants to prove that if given the right tools and a fertile environment, motivated youth can do extraordinary things. But what makes YA/YA different from most programs that benefit youth is that *the YA/YAs make money* doing something they enjoy—making a product that they can sell. It is therefore extremely important that they receive a significant part of the proceeds from the sale of their work. Otherwise YA/YA would be just another entity that takes advantage of young artists.

From the beginning, Jana allowed the YA/YAs to sell their artwork in her gallery and take home a percentage of the sale price. Today, entry-level and apprentice

(younger, beginning) YA/YAs take home 50 percent of their sales. Guild members get 80 percent. For high-school Guild members, a portion of that 80 percent is set aside to be given to them as a "bonus" when they enroll in college. College Guild members receive their full 80 percent when they make a sale. The rest of the money is plowed back into the organization to help cover operating expenses.

Money and Trust

Money is a vehicle. We use it to go places, to do things, to value our work, and sometimes even ourselves. Knowing how important it is, especially to some people, we are surprised and pleased when we feel trusted with it.

January 1994. Darlene Francis is about to leave the YA/YA program. She has been with us since the beginning, fought hard to be included in the first group of students to be invited into the studio. She illustrated her first book through YA/YA, and her design for a child's chair was selected and painted 150 times over for sale through the prestigious Hammacher-Schlemmer catalog. Darlene has decided she has learned what she could at YA/YA and now it is time to go do something else. We wish her well.

Darlene the frugal. If any one of the YA/YAs could be called the wise squirrel who saves nuts all summer to prepare for winter, it is Darlene. Always asking top dollar for her storytelling designs, she is thrifty and a bit of a miser. She sells a midnight blue chair with Boonchee flying on a magic carpet and leaves the money in YA/YA's bank account, saving it to buy a car or something else she envisions for herself down the line. At one point her savings in the account amount to more than $5,800. We feel great about that. Darlene has trusted YA/YA with her money more than she trusted a bank or her mattress or anyone else. We hand it over to her, grateful for the role she let YA/YA play in her life and in the beginning of what will surely be her fame and fortune.

Detail of Print YA/YA "Monkey Fabric," 1992

93

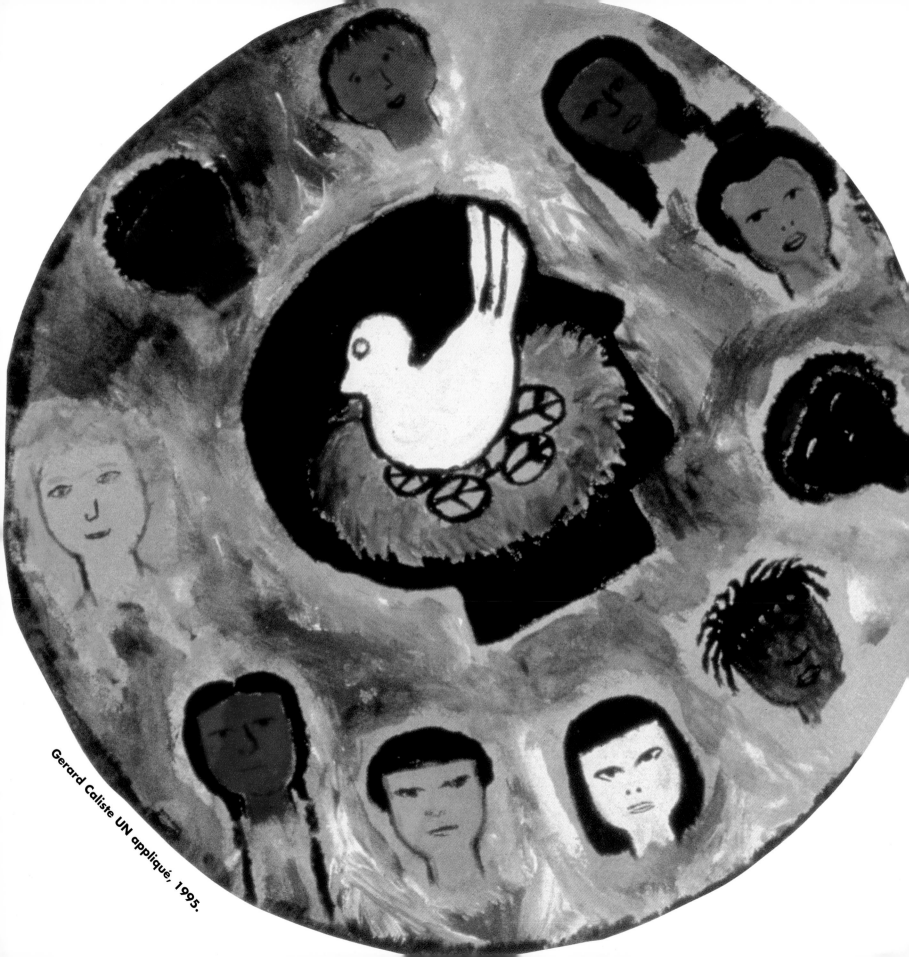

Gerard Caliste UN appliqué, 1995.

chapter 6
GROWING UP

I think the basic thing that happened with YA/YA is that it started and we became a family before we became an institution, even though the family seems a lot more interesting than the institution. But we actually got to know each other as individuals, as a family, and we grew. We argued, we cried, we lived, we had dinner, we grew.

—Darryl White, addressing the National Council on the Arts, August 5, 1994

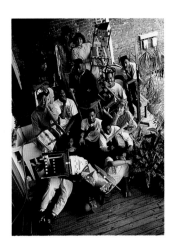

YA/YAs, 1991.

Photo by J. Dexter Stewart, New York.

N many ways YA/YA resembles a family more than it does an art gallery, school, or community center. Although, as in a gallery, there is a space to display artwork, and as in a school, students gather there regularly—afternoons and weekends—to receive a specific kind of training, YA/YA feels and functions more like a household than an institution. First, there are young people who share the common bond of creativity. Among these young people there are various generations, starting with the very first YA/YA Guild members and continuing across the spectrum to the newest recruits. Various staff members resemble parental figures, big sisters and brothers, and even a grandmother or two. Older

YA/YAs serve as mentors for younger ones. There are even little kids in the environment sometimes—staff members' children and YA/YAs' little brothers and sisters—running around the space, crayons in hand, ready to join in the fun.

In addition to the people and their personalities, there is another strong familial link: the YA/YA art. The work created by the first YA/YA Guild members started a tradition, a tangible incarnation of the YA/YA spirit and style, that turns up in the work of subsequent "generations" of YA/YAs. Not only does the work have a certain "look," but in some instances younger YA/YAs actually incorporate images by and of the older YA/YAs into their own work, weaving the thread of YA/YA's

Monica Scott's minihouse *Art School*, 1994. Below: detail of minihouse.

Photo by Michael P. Smith, New Orleans

history into the fabric of their own personal creativity.

September 21, 1994. The YA/YAs are hard at work on their pieces for the upcoming Art for Arts' Sake show, to be held this year at the newly expanded Louisiana Children's Museum. At least three thousand people will see the work, most of them on opening night, which is less than two weeks away. We all stop for a few minutes during our regular Wednesday meeting to do a critique of the works in progress—in this case miniature houses, each with one open side, featuring doll-sized YA/YA furniture and fabric.

The minihouse by Monica Scott, a fourth-generation Guild member, generates much discussion. Monica has transformed her house into an art school. She has carefully crafted draftsmen's tables from what appear to be small spiral notebooks turned horizontally, painted bright jewel tones, and set on pedestals in the shape of the numerals one, two, and three. The effect is strikingly original: a whimsical Dr. Seuss–like tableau that sits waiting for tiny students to come and occupy it.

The interior and exterior walls of the little schoolhouse, however, are not so original. Monica has chosen to interpret them literally, pasting pictures cut from magazines on the walls to represent the posters that might adorn a typical art-school studio. A lively discussion begins about whether it is appropriate for Monica to use published images, which are essentially the work of another artist, in her design. Ms. Neske suggests that the only way to do so is to alter the images in some way. Apprentice Eddie Washington says that she could paint mustaches on them all like Marcel Duchamp. Everyone laughs. Monica agrees to rethink her piece in order to make the walls as interesting as the furnishings.

A couple of days later we look at Monica's house. She has taken most of the "posters" off of the walls and replaced them with hand-made items. But that isn't all. Monica covered the outside of the house—its sides, back, and roof—with drawings of various YA/YAs in poses taken from photographs. She has drawn some of the portraits with a thick black paintbrush,

then whitewashed over them and superimposed, with a fine black pen, other portraits, some full-length and detailed. The thick figures look like ghosts inhabiting the walls of the house. The penned figures are sophisticated caricatures, drawn by someone who knows her subjects' mannerisms and style of dress. Former YA/YA Lionel Milton appears in his signature horned-rimmed glasses and loose baggy pants. A lanky figure slouches against the side of the house. The backwards baseball cap tells us it is Eric Russell.

Monica has managed to paint the essence of the YA/YA "family" and the many layers of the YA/YA experience: successive generations of YA/YAs *one on top of the other,* a colorful environment for learning, the YA/YAs' images and their strong spirits literally etched into the walls of the place. That's how it *is.*

Family Dynamics

Of course, as in any family, things aren't always smooth. YA/YA has its ups and downs, and since the place isn't very hierarchical, there tends to be a good deal more conversation about them than one would find in most business environments. Over the course of its history, YA/YA has evolved from an unorganized hodgepodge of curious high-school students receiving intense one-on-one training from Jana to a much larger program trying to serve both high-school and college students through the application of a long list of byzantine

rules and regulations, and most recently to a third incarnation that combines the best of the two extremes. Getting there, however, hasn't always been easy.

June 1993. YA/YA is closed for two weeks. Clif St. Germain, a friend and educational consultant, has told the staff that we are crazy for opening our doors six days a week with virtually no break from January to December. We breathe a collective sigh of relief and tell the YA/YAs to take a holiday, we are going to sit down and plan the year. We convene daily afternoon marathon sessions, each devoted to a different topic, ranging from the schedule of shows and trips to more basic issues such as "What's the purpose of the program?" and "Who do we really want to serve?"

Madeleine Neske sees YA/YA's focus as most appropriately directed toward her Rabouin students. She says, "I have a personal commitment to everybody I'm working with. I can't separate myself from them being my students. I'm very possessive of all of my students. Those are my *kids.* I want them to succeed, and I have a lot of students who are not getting the benefits of YA/YA." But Jana and some of the other staff members feel a huge responsibility to the YA/YAs who have graduated and gone on to college. "We haven't done anything if we don't help them get through college and get jobs," Jana says. Madeleine is doing her job, being an advocate for the younger YA/YAs, trying to get the others to

club emixx, Eric Russell, 1994.

Photos by Michael P. Smith, New Orleans

***Night Angel,* Tarrie Alexis, 1994.**

Photo by Michael P. Smith, New Orleans

Time Is Running Out, Shazell Johnson, 1994.

Ron Ratliff, *Number 15 in the Corner Pocket,* 1994.

Eric Russell, *club emixx* (rear view).

Tarrie Alexis, *Night Angel.*

Darryl White, *Shadows and Silhouettes,* 1994.

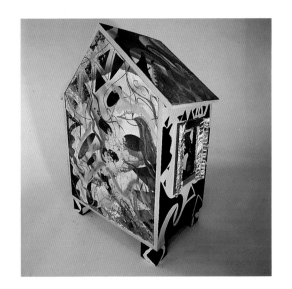

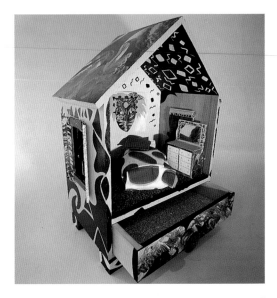

Chris Paratore, *Untitled,* 1994, rear and front views.

98

understand that the organization has limited resources—staff time, studio space—that should be divided equitably. We try a compromise, limiting the amount of time the college YA/YAs may spend at the studio when the younger YA/YAs are there. Still the issue persists, causing tension among staff from time to time.

It's not only the adults, however, who create friction in the environment. The older YA/YAs have been known to vent their frustrations on the younger ones, too. Just as in a family, the older guys are watching the adults; the younger guys are watching the older guys.

Carlos Neville explains how the older YA/YAs felt about the first group of new students: "We had been there for a long time without no one else coming in, nobody even seeming interested. It was like our organization, this is for us, we had made our deal. So when some other kids came in...I was just like, Who are they? I had never even learned y'all's names for a whole year. We felt we owned it."

Such resentment looks and sounds and feels a lot like how only children feel when a little brother or sister comes along. Reactions run the gamut from elation ("Now I have somebody to play with, somebody to blame!") to mischief ("Let's see what happens when I set his clothes on fire!"). Of course, as in a family, there are genuine feelings of love and affection once some rapport has been established. And when that is combined with some skill, real mentoring relationships develop. Older students pass on their talents, their good tricks, their shortcuts, their experience to the younger ones. The training cycle turns, stopping every once in awhile to let someone off, pick up someone new. Students become teachers. Younger ones not only listen to what the older ones say, but also watch what they do. Just like adults, the older ones become role models *whether they want to be or not!*

"As everybody grows up, things change," says Chris Paratore. New YA/YAs suddenly begin to know how to paint. They're not new anymore. Then the really new ones come in, not knowing much of anything. For a few months. Then they create something that makes us all stand there in amazement. Then they leave a paint can open and waste thirty dollars' worth of paint. Rondell Crier says, "You should expect when new people come in to...act crazy. You should expect it already and try to find out how you gonna handle it."

Handling it is a process, not an event.

"What works is that kids need time, and no matter how stupid you are, if you give it to them it works."
—Jana Napoli, 1994

As in a family, time is the key: working with young people day after day, with them knowing you are going to be there, at least when you say you will be there. This is what works. Young people desperately

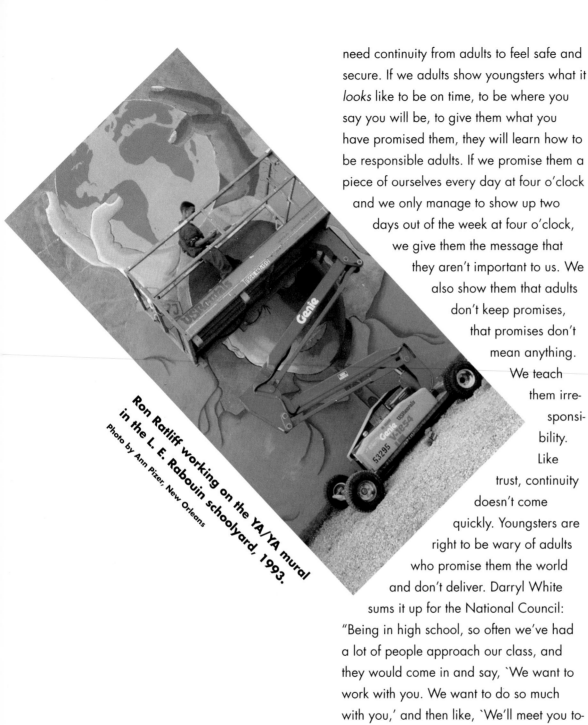

need continuity from adults to feel safe and secure. If we adults show youngsters what it *looks* like to be on time, to be where you say you will be, to give them what you have promised them, they will learn how to be responsible adults. If we promise them a piece of ourselves every day at four o'clock and we only manage to show up two days out of the week at four o'clock, we give them the message that they aren't important to us. We also show them that adults don't keep promises, that promises don't mean anything. We teach them irresponsibility. Like trust, continuity doesn't come quickly. Youngsters are right to be wary of adults who promise them the world and don't deliver. Darryl White sums it up for the National Council: "Being in high school, so often we've had a lot of people approach our class, and they would come in and say, `We want to work with you. We want to do so much with you,' and then like, `We'll meet you tomorrow.' Come tomorrow, no one's there. But Jana actually didn't do that."

She showed up. Plain and simple. You want to work with youngsters? You show

up. And if you have some special skill to offer them, you give them that with your heart and your head and everything that you can remember about how you learned what you know.

In Jana's case, what she knew was painting. "I kept drawing pictures. I wouldn't use words. I'd draw against them and say, `Is this what you mean?' That way they can defend themselves. Whatever images they keep putting back in, that's what you know is important to them."

Darlene Francis talks about how best to teach: "You shouldn't try to make a person change, because you don't know what's inside their heads and what's inside their heart, their conscious or subconscious. Whatever it is they're trying to do, you should just let them do it and try to help them on the technique, making sure that it doesn't look tacky."

You don't have to know how to paint to help youngsters, to make a difference in their lives. What adults have to give can be anything. It can be help with homework. It can be help filling out a financial-aid form for college. It can be an afternoon snack. It can be teaching someone how to use a bandsaw or write a letter. Sometimes it is just sitting there, doing your own work, but knowing that the students know that you are there for them and that you will be there for them until they finish their work.

Carlos Neville says, "I always did mention to people who came in and asked about how they could do it, I say, `If any-

body in the community has access to an old factory or building and have some type of skill and they're retired, that they can offer to the kids..." This is what YA/YA did. This is how to YA/YA.

Jana agrees. "If you do great at something—a welder, a plumber—and you do beautiful work, whatever it is that you love, then you can share it with someone and they've got something to learn. I love my profession. I love painting. I have ultimate respect for making images. I think it's important, the pictures you make. I felt that they should be honest. Images are important. And people look at them in here and they pick all kinds of stuff out of them. That's important to me. You have to be confident in the profession you are trying to share."

That is the reason that YA/YA adopted the concept of the guild, in which more experienced craftsmen share their expertise with younger apprentices in order to create a product that they can sell to make a living.

In working with young people, it is vital that the adults who are "in charge" be of sound mind and spirit. We do not say this lightly. Whatever your problems, if you do not recognize them and consciously work to resolve them you will pass them on to the next generation. This is as true at YA/YA as it is in a family. So those of us who work with young people must be extremely vigilant—hyperaware, in fact—of our fears, our shortcomings, our resentments, and our

flaws. We must work to fix them in a diligent and methodical manner. Otherwise they become ingrained in our "offspring," who then pass them on to the *next* poor, unsuspecting group of youngsters.

The Value of Structure

Wednesday, September 21, 1994. Meeting with the YA/YAs about final arrangements for the show that opens in ten days. "You have to have your pieces finished by next Tuesday," I say, "so that they can be varnished and can dry before we install the show on Friday. Okay? Everybody understand that?" One of the YA/YAs says, "What's the real deadline?" "What do you mean?" I ask. "I mean, you know how you all always say the deadline is this day, and then everybody just keeps working right up until the last minute and you all let `em do that. So what's the real deadline? I mean, when do we *really* have to have it finished or else it can't be in the show?"

We're busted. We know in our hearts that what this person is saying is absolutely true. We have institutionalized a laissez-faire attitude about deadlines so much that no one respects them anymore. Clearly it's the adults' fault. In an effort to be "nice," to go the extra mile for the YA/YAs, to be as flexible as we possibly can, we have managed to teach them that deadlines aren't real, aren't important, aren't to be respected. Although we may have had the best of intentions, we have done the young people a disservice. The same thing hap-

pens when we fail to suspend or expel someone who breaks a cardinal rule (such as the need to be enrolled in school in order to participate in YA/YA). The organization takes a labored breath, and a grimace creeps across its collective face. We think we are just bending over backwards to hold on to someone. The others think we are playing favorites.

What we have learned from this is that we must make reasonable rules and then enforce them without exception. It's hard because sometimes we are itching to see a young person succeed and are seduced into believing that if only we give him or her the benefit of the doubt, or a little extra time or special dispensation, then maybe, just maybe, he or she will come through, finish the project, graduate from high school, live a happy life. What we have found instead is that breaking our own rules leads others to disrespect them. We put ourselves in the position of enabling students to circumvent the system, which gives them a false view of life. It ultimately causes a kind of helplessness in them, an inability to deal with the demands of doing business, even a false sense of entitlement.

Of course, sometimes the system works against young people. Rondell Crier: "They got teachers that the students say, 'You're not teaching me good enough.' So they might say, 'Well, you just ain't trying hard enough.' But some people just teach wrong. They teach and nobody in class learns and everybody be failing and, I guess, then they start passing who they want to pass and failing who they want to fail and you can't do nothing about it. Even if you knew all of it before you got in his class, it's still, the way they teach, you just don't pass. But you can't do nothing about it because your voice is not heard."

Is it right that young people's voices are not heard? And perhaps an even more important question: Is their lack of access and power working to anyone's advantage? Or is it just an example of one group trying to keep another down? Remember: historically, oppressors have been people who, above all else, feared losing control.

June 1994. The YA/YA staff and alumni (college YA/YAs) are sitting around a big table talking about how best to make the most difficult decisions—for example, which students get to go on trips and compete for the most lucrative jobs. Staff has always made those decisions and always been criticized for them. "Just once," one of us says, "I would like for you guys see how it feels, how hard it is, to decide who deserves to go on a trip." Someone hits on a brilliant solution: turn this responsibility over to a committee made up of both YA/YAs and staff. Give that committee all the information it needs, such as YA/YAs' records of participation and grades. Have that committee meet regularly to decide these tough questions, and make the committee's judgment final. Heads nod. Seems workable, doesn't it? The YA/YA Committee is born.

This may not seem earthshaking, but to the staff and young people of YA/YA it is the first step in grooming the YA/YAs to take ultimate responsibility for the organization. And that is as it should be.

Making Them Investors

Fall, 1993. YA/YA begins employing some of the YA/YAs as interns. Courtney Clark serves the office as administrative intern, and Chris Paratore works in Print YA/YA as production intern. The YA/YAs perform so well in their jobs that YA/YA decides to hire several more interns, with turnover each semester to give others a chance to compete for the positions. An internship is both a part-time paying job and an honor. It is prestigious to be a YA/YA intern. Competition is stiff and the positions usually go to hard workers who bring a positive attitude along with an excellent portfolio of artwork.

After nearly eight years of doing YA/YA, we keep coming back to the same conclusions: that the YA/YA organization should belong to the young people it serves, and that it is the adults' responsibility to make sure they are given the tools they will need to run it. Part of what they will need to run it is experience, which comes from having the chance to make decisions and implement them—which means the adults have to step back and allow young people to do this.

So we let go. We relinquish control a little. And we give some to the young peo-ple so that they may learn to use it. Perhaps most important, we create a means by which the YA/YAs will have direct input into the major decisions that they most care about. They learn respect for one another and for the process of decision making. They learn about compromise. They learn how hard it is to be fair all the time. YA/YA benefits greatly from their insight and their hard work. A new generation of young adults begins to make the decisions about the face of the organization—literally, which faces represent YA/YA on jobs and on the road. It is an important moment in our organization's development, perhaps even more important than the YA/YAs realize.

This step is hard for us, as it would be for any concerned parent, teacher, or adult working with students. What if they take the organization that we have worked so hard to create and they fail? What if they make mistakes? So what! We did!

June 1992. On the road in Europe with the YA/YAs. I am trip manager, ticket purchaser, banker. I spend most days counting money, writing things down, making lists, trying to keep a dozen YA/YAs in one place and safe. I lead the way to the train station, stare at a map, go to the ticket counter, try to make myself understood. I ask directions or buy tickets for everyone, then return to the group and say, "This way!" and start walking.

Sometime during the trip, one of the YA/YAs complains: "Why you always tak-

Chair by Charles Cooper, 1996
Photo by Michael P. Smith, New Orleans

103

ing off and we have to follow you? I mean you just disappear and then come back and we all just standing there!" I think about this. I realize how these very capable people must feel when I do not give them the opportunity to help make the travel arrangements or find out which way to go or hold on to the passports or keep the receipts. I literally deny them the opportunity of learning how to travel. They feel disenfranchised. Powerless. Helpless. I learn a great lesson and do things differently next time.

Unless we allow them to take power, how else will they learn what it means to grow up? Jana tells the members of the National Council on the Arts, "We fought like cats and dogs, and the kids refused absolutely to grow up unless I did it first." Everyone laughs. But she is telling the truth.

"Just because your body grows older doesn't mean you're actually an adult."
—Darryl White, addressing the National Council on the Arts, 1994

Most of us don't grow up until we are approaching middle age. Think about it. When did you first feel grown-up? When you graduated from college? Got a job? Got married? Had children? Or was it one Saturday morning when you woke up and knew exactly what you wanted to do and went and did it. Being grown-up is a feeling that comes when our adolescence—that time in our lives between puberty and matu-

rity—ends. It's often accompanied by nostalgia, which most always comes out of a sense of loss.

Adolescence is scary. It is filled with possibilities, the new awakening of our sexuality, and the beginning of big questions about ourselves. Consequently it is also a time of much turmoil, fear, and rage. Adolescents look at what adults promised them, their images from childhood, compare those pictures with the real world, and get angry. They rail against authority and denounce hypocrisy. That's their *job*.

So-called adults see this and are reminded of our own adolescence. Our response to these big scary pictures is often to slink quietly out of the room and complain that our children are incomprehensible. People who are of adult age chronologically but who have not resolved their adolescent feelings—in other words, most of us—are petrified of dealing with youngsters. We are literally "irresponsible"—unable to respond—when challenged by young people, whether it be about the state of the world adults have made or the reason for a particular rule. We hear things like "That's just the way it is" or "Because I said so" coming out of our mouths, and we remember our parents saying that and cannot believe we are saying the same thing. But we don't know what else to do. We don't have the answers. Our parents weren't grown-up either.

The only solution is to allow youngsters to take some control over their own des-

tinies, to let them push the big buttons that will ultimately catapult them out of adolescence and into responsible adulthood. Training for adulthood involves allowing young people the opportunity to make decisions, make mistakes, and take consequences. Like training for the space program, it is demanding, it is risky, and it occasionally involves being turned upside-down.

The Struggle of Growing

May 5, 1993. Staff gets a letter signed by several of the YA/YAs. It starts off, "What does the term `at risk' mean? In our opinion, it describes someone or thing that is a danger to their society. YA/YA has fed off of this term, `at risk,' and has failed to justify their reasons for doing so. To say you use the term `at risk' because we are all `at risk' and any one of us could get killed today, is both a cop-out and a lame excuse. Yes, it's true that society at large isn't safe, but you can't generalize a group of high school kids in order to get grants. It's immoral, and very demoralizing. Basically it's conforming to white society's prejudices about minorities. They want us to be `at risk' because it keeps us `at risk' mentally. If you keep telling someone, you're a nothing, you'll never be as good as you think you are, people start to believe it."

Strong words from a bunch of "adolescents." The letter gives us pause. We have given the YA/YAs the power to speak out, and they speak loudly and clearly. In addi-

tion to anger over the use of "at risk," the letter states the YA/YAs' desire to suspend the weekly group-counseling sessions that YA/YA requires they attend and criticizes the staff for failing to have YA/YAs and their parents ratify the newly created YA/YA Charter.

The experience is an empowering one for the YA/YAs. Gradually we begin hearing more from them—about the way they are portrayed in the press, about their frustrations with the adults who run YA/YA, and about the way they see themselves and the organization. As the young people grow up, they demand that the organization change to accommodate them. Staff resolves not to use the term *at risk* to describe the people who participate in the YA/YA program.

As the organization changes and grows, it attracts more and different people—ones who think of YA/YA as an institution that they are bound and determined to join. The earliest YA/YAs came because they were curious and wanted to do artwork; the people who now compete to join YA/YA do so because it is a prestigious extracurricular activity that will afford them many opportunities. The first YA/YAs were pioneers who cut a trail for everyone else. Their success made YA/YA the desirable place it is for everyone who comes after them.

Apprentice Caprica Joseph says she was determined to make her way into YA/YA, even though she is younger than

Caprica Joseph's chair for New Orleans Jazz Fest headquarters, 1994.

Photo by Michael P. Smith, New Orleans

most of the students YA/YA normally takes. "I said, `Oh, no! They not lettin' in no ninth graders!' And I said, `Oh, yeah? I'm gonna get in.'" So she starts coming to YA/YA every day after school and volunteering for jobs and projects. She paints YA/YA desk ornaments. She paints her first baby chair. It sells to some tourists before she even has a chance to photograph it. She makes herself known in the organization, she talks to everybody, she watches what the older YA/YAs do, and she paints and paints. She becomes a part of the YA/YA family.

And the family grows up. We watch the YA/YAs handle themselves and their clients, and we begin to see young professionals. We remember how they used to be and we make comparisons and we smile at the leaps and bounds a young person makes in a few short years.

Doing Business, Gaining Perspective

November 1993. The YA/YAs have been commissioned by a company called Bishop Partners in New York to make 150 miniature chairs, in six different designs. The company chooses two designs by Edwin

Chris Paratore's minichairs for Bishop Partners, 1993.

Photo by Jana Napoli, New Orleans

Riley and one each by Chris Paratore, Tarrie Alexis, Darlene Francis, and Shazell Johnson. Rondell Crier gets the job of art director. He runs the project, deals with the client, gets the wood cut to make the chairs, puts them together, and makes sure everybody does his or her work in a timely manner.

It is, however, the job from hell. It is like a giant cuckoo clock with hundreds of moving pieces that must click into place in order for it to work properly. Nothing clicks. Everybody is trying hard, but the YA/YAs don't have any idea how complicated a job it is or how long it will take. Almost everyone is late submitting designs—and time is a problem because the older YA/YAs are rushing to get the job finished during their holiday break from school and the client is anxious for delivery. Rondell is trying to keep on top of five designers to design and then paint the chairs. The work is uneven and some of it has to be redone. Rondell not only has to order special small boxes to package each little chair, but also has to go and get the boxes and assemble them. Mrs. Dennis, YA/YA's operations coordinator, gets stuck staying half the night to get the pieces boxed and shipped on time. The client isn't happy with the quality of some of them, which come back and have to be repainted. The job drags on and on. It is the first job that the YA/YAs really manage on their own, and they learn great lessons in doing it.

A year later Susan Bishop calls again.

For the tenth anniversary of her business, she wants to commission a poster that features one of the little chairs, shown from a variety of angles, above her company's name. This time the YA/YAs are ready. Shazell and Rondell talk to Ms. Bishop to determine exactly what she wants, how much she is willing to pay for it, and when she needs it. They negotiate the terms of the job and collaborate with the other YA/YAs on the poster design. Together they create a tight design that the client approves, and they provide finished artwork that sings, and they do it on time. The client is happy.

The YA/YAs are happy, too. They feel good because they get repeat business from an important client who took the time to engage in their learning process during the first job. Ms. Bishop is willing to deal directly with the YA/YAs and holds them accountable for the quality of their work. Working with her enhances their professionalism, helps them along their path of self-sufficiency. After the job is done, they are a little closer to grown-up. And they are aware of the difference between how they handled the job a year ago and how they handle it now. They gain perspective.

And they become colleagues. From collaborations like this one the YA/YAs learn who possesses which skills, who can be depended upon to do which piece of a job. Now, when one YA/YA gets a commission, especially a commercial art job, he or she

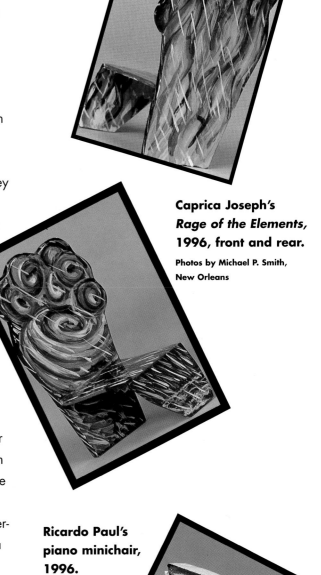

**Caprica Joseph's
Rage of the Elements,
1996, front and rear.**
Photos by Michael P. Smith,
New Orleans

**Ricardo Paul's
piano minichair,
1996.**
Photo by Michael P.
Smith,
New Orleans

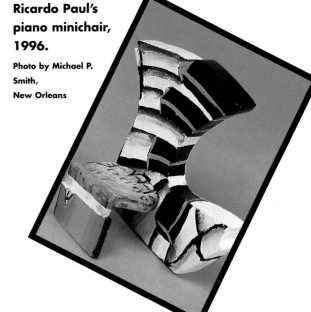

Sketches by Caprica Joseph (left) and Gerard Caliste, 1995.

often calls upon another YA/YA—or former YA/YA—to help.

Gaining Perspective

October 1994. Eric Russell and Carlos Neville visit Ms. Neske's commercial-art class at Rabouin High School. Everything is chaos. Too many students are trying to draw and paint in a small space, they are laughing loud and ribbing each other and not paying real attention to the assignment. Madeleine is doing her best to keep order in a crazy, creative environment full of boisterous sixteen-year-olds. Afterward she asks Eric and Carlos if they have any suggestions about how she could handle the class better. "Nope," Eric says, smiling and shaking his head. "No recommendations?" she asks her alumni. "Nope," Eric repeats, and looks right at her. "There's not a thing you can do. It's just their age."

The Very Big Picture

When we really look at what we are doing at YA/YA, at how much what we are doing affects people's lives, we are overwhelmed. The time, attention, and money, the pieces of ourselves that all of us—staff and students—invest in this YA/YA "monster" (as former staff member Lyndon Barrois once called it) are enormous. It is by no means "just a job" for any of us who work here. It is by no means "just an extracurricular activity" for any of the young people who come here every day.

Doing YA/YA is a commitment, pure and simple. By investing so much of ourselves and so much of other people's money in YA/YA, we are making a contract to be good stewards. The responsibility is a shared one. Both students and staff are stating, every single day, that what we are doing is important and that we will strive to do our very best with what we have been given. And we have been given so much. Money from generous people, the space, both physical and emotional, in which to grow. YA/YA is a kind of laboratory in which we all come together to perform a noble experiment with one anothers' lives. Can we really make a difference, a long-term difference, in how we live with one another? Can we really affect the *quality* of one anothers' lives?

The answer is yes, or else we wouldn't be doing this. Jana tells the YA/YAs: "Think about it. Try to work hard. Get out there and do your best because it's a lot of money and some other kid could be eating off this plate." Participating in the experiment is a big responsibility. It means being far more serious than the average adolescent *or adult* tends to be about doing one's job. It means being responsible. And it is doubly hard because the more press attention and opportunities come YA/YA's way, the bigger the stakes and the more we have to lose. And if we lose it, we lose it for everyone—not just for the young people we currently serve, but for all those who might have come after them, and for every young person around the nation and world

who might have benefited from YA/YA's success. If we lose it, if we don't meet the highest standards of performance, then we make right all those people who look at YA/YA and say, "Those are just kids! Who do they think they are?" We give credence to every naysayer, every detractor, every person who gains something by denigrating what the YA/YAs have worked so hard to do.

So our message in the YA/YA laboratory, to ourselves and to the students, is to use resources wisely—whether it is in the form of your own time, someone else's time, or the contents of a brand new paint can—or you may not get any more.

There is another kind of stewardship that is vital to YA/YA and is paramount in any endeavor whose focus is on young people. It goes beyond banking and bookkeeping, it is far more important than being written up in the newspaper, and it transcends the daily rules by which we run the organization. It is the careful stewardship of young people's souls. Sound awesome? It is.

When a youngster chooses to participate in something like YA/YA, it is as if he were walking carefully down a hallway, heart and soul held lightly in cupped hands, offering the best pieces of himself to relative strangers waiting at the other end. It is a risky business, particularly if that young person is asked to reach down into the depths of his experience and pull out images that mean something to him, draw

them on a piece of paper, and then share them with others. The amount of trust involved is enormous. Therefore, the way we receive those images, the level of respect we give them and the person who made them, is critical. We adults must value the creativity and the spirit of young people and guard it from harm. It is the job of adults to serve as advocates for the young people who entrust us with themselves. This means not competing with them and not envying their success—or trying to own it—even if we help them achieve it.

Adults, who presumably see a bigger picture than youngsters, must act as catalysts, as gadflies—goading, pushing, often annoying young people into action. Sharon Riley, mother of YA/YA Guild member Edwin Riley, witnessed Jana Napoli's tactics. She describes them to a group of the students: "She was a thorn in your side just like you were a thorn in hers. She got you to clean up and she got you to do this and that. And you showed the people on the outside, 'I am worthy to be here.' And you showed the people on the inside, 'I am worthy to be here.' And that's why it works."

Another reason it works is because as the YA/YAs grow up, they venture out of the organization. Trips to other cities, schools, and organizations allow the students to experience other environments. Internships in other places allow them to work in new frames of reference. The students know the value of this. Rondell Crier,

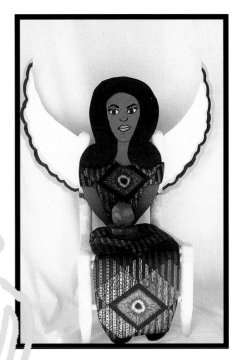

Channel Guice, *Mother Earth Angel,* **1996.**
Photo by Michael Eder

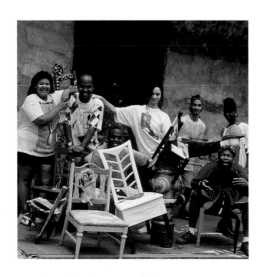

YA/YAs in the French Quarter, 1992.
Photo by Michael P. Smith, New Orleans

who has had internships in Washington and Chicago, advocates encouraging students to leave the nest. "Y'all see somebody staying at YA/YA—push them! When they get old enough, shove them away! Go see around before they trap themselves and then when they get older they like, `God, I wish I could have been...' Who knows, maybe they might leave, maybe they might like it. Maybe they might come back on their own. Let them." He also says, "All kids need a life. You have to have fun—a fun life."

The Model: Take What You Like and Leave the Rest

If we have learned anything through the YA/YA experience about working with talented youngsters, it is that whatever works should be shared. YA/YA can offer the world a model of how to take young people from one level to another. The point of sharing what YA/YA has done, whether it be in training sessions in other cities or through this book, is not to say, "Look how great we are," but rather to say, "Look how many mistakes we made and we still managed to do something extraordinary! Don't be afraid to try!"

Bill Strickland, a National Council on the Arts member and founder of the highly successful Manchester Craftsmen's Guild in Pittsburgh, suggests that YA/YA may have something to offer: "I think that you should be replicated in every community, in every child's life in this country, without a doubt.

The kind of thing that you're representing here today in its elegance and its simplicity is precisely the path of hope that our nation's youth have lost."

National Council member Wendy Luers comments on the importance of investing in individuals, in the Jana Napolis of the world, who have the vision and the passion to make an experiment like YA/YA a success: "We can't clone you, but we should try to define what the `you' is."

It is a tall order. The "you" must include the artistic vision, the space, the money, the interested young people, and the generosity of many individuals. But perhaps most important, the "you" must include the passion and, as Cheryl Bowmer, NEA site visitor, calls it, the "single-mindedness" that drives Jana Napoli and people like her who want to work with youth. Therein lies the magic that makes any "noble experiment" a success. This driving force is also what will make each "experiment" unique.

There can be no other YA/YA. But there can be any number of successful efforts in which caring adults work with youngsters to nurture their creativity and teach them to make a living. It might be through writing, or through performance, or through some specialized craft or skill. The key element is having adults who know how to do something well, love what they do, and have the desire to share it with younger people. If you really have this, then everything else— the space, the money, the young people, even the product—falls into place.